Praise for D̶o̶u̶b̶l̶e̶ ̶T̶a̶k̶e̶

W9-BZX-371

"Kevin Connolly has used an unusual physical circumstance to create a gripping work of art. This deeply affecting memoir will place him in the company of Jeannette Walls and Augusten Burroughs."　　—Sara Gruen, author of *Water for Elephants*

"[A] charming memoir. . . . Connolly recounts growing up a scrappy Montana kid—one who happened to be born without legs. . . . [*Double Take*] makes for an empowering read."

　　　　　　　　　　　　　　　　　　　　　　—*People*

"A courageous, immensely rewarding chronicle expressed in arresting words and pictures."

　　　　　　　　　　　　—*Kirkus Reviews*, starred review

"Life's most successful survivors meet adversity head on, with an unflinching eye, candor, and with humor. Kevin Connolly has such an eye and weaves a rich memoir from the gut about his amazing journey through life."

　　　　　　　　　　—Lee Woodruff, author of *In an Instant*

"Beautiful, revealing, and stimulating. . . . [Connolly] is a good storyteller . . . whether describing his first high school wrestling match, the path from novice to champion skier or what it's like to travel around the world on a skateboard."

　　　　　　　　　　—*Publishers Weekly*, starred review

Double Take

A Memoir

KEVIN MICHAEL CONNOLLY

harperstudio

An Imprint of HarperCollins*Publishers*

The names and identifying characteristics of some individuals have been changed to protect their privacy.

Page 47, photograph of Kevin Michael Connolly on his mono-ski at Big Sky, Montana © 2009 by Bob and Estela Allen; page 230, author photograph © 2009 by Sarah Nutsford.

A hardcover edition of this book was published in 2009 by HarperStudio, an imprint of HarperCollins Publishers.

DOUBLE TAKE. Copyright © 2009 by Kevin Michael Connolly. All rights reserved. Printed in the United States of America. No part of this book may be used or reproduced in any manner whatsoever without written permission except in the case of brief quotations embodied in critical articles and reviews. For information address HarperCollins Publishers, 10 East 53rd Street, New York, NY 10022.

HarperCollins books may be purchased for educational, business, or sales promotional use. For information please write: Special Markets Department, HarperCollins Publishers, 10 East 53rd Street, New York, NY 10022.

For more information about this book or other books from HarperStudio, visit www.theharperstudio.com.

First HarperStudio trade paperback edition published 2010.

Designed by Leah Carlson-Stanisic

The Library of Congress has catalogued the hardcover edition as follows:

Connolly, Kevin Michael, 1985–
 Double take : a memoir / Kevin Michael Connolly.
 p. cm.
 ISBN 978-0-06-179153-6
 1. Connolly, Kevin Michael, 1985– 2. People with disabilities—United States—Biography. 3. Leg—Abnormalities—Patients—United States—Biography. 4. Athletes—United States—Biography. 5. Connolly, Kevin Michael, 1985– —Travel. 6. Voyages and travels. 7. Skateboarding. 8. Helena (Mont.)—Biography. I. Title.
 CT275.C76385A3 2009
 613.7'11092—dc22
 [B]
 2009030496

ISBN 978-0-06-179152-9 (pbk.)

10 11 12 13 14 OV/RRD 10 9 8 7 6 5 4 3 2 1

AUTHOR NOTE

All but one of the images in this book were part of The Rolling Exhibition, a collection of photographs taken during my travels around the world.

double take \\'də-bəl-ˌtāk\\

A rapid or surprised second look, either literal or figurative, at a person or situation whose significance has not been completely grasped at first.

Soon after we can see, we are aware that we can also be seen. The eye of the other combines with our own eye to make it fully credible that we are part of the visible world.

—John Berger, *Ways of Seeing*

CONTENTS

BIRTH DAY

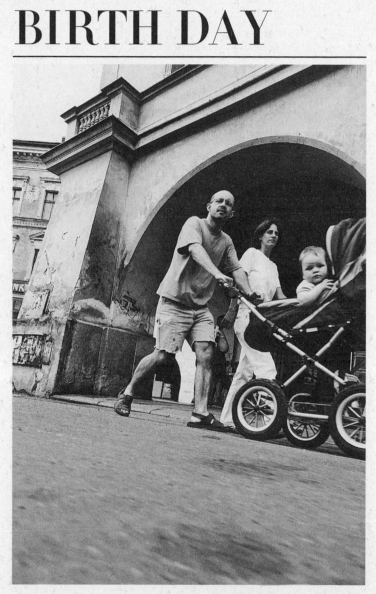

Mělník, Czech Republic

"You were an exclamation point on a really tough couple of years" is what my mom says about my birth.

I am calling my mother from my apartment in Bozeman, to ask her about something I've always wanted to know but have been a little reluctant to delve into. Up until now, I'd always avoided asking too much about the time directly following my birth for fear that it might bring back feelings neither of us wanted to deal with again.

But first we must have the obligatory talk about Montana's mercurial spring weather. After a week of blizzards and deliriously frigid temperatures, the cold had let up long enough for the snow to turn into a brown goulash of dirt and ice. It's the time of year when most people become homebodies, seeking anything that is warm and dry.

Except, as Mom quickly tells me, a good portion of our home is now submerged in water. Earlier in the day, a pipe had sprung a leak and had emptied gallons into the kitchen, soaking through the floorboards and down into the basement.

"The kitchen is totally flooded. The whole floor is going to have to be replaced."

She sighs, then laughs.

"Oh well. Been through worse."

I imagine the kitchen, swollen and bloated, weeping out the old mold and dust of our family's history. I know that Mom and Dad will patch it back together themselves, and Dad confirms my speculation by yelling over Mom that he's going to the hardware store later. He's already had a couple of beers, by the sound of his laugh.

My parents don't have much money; they never did. There is a picture in the entryway that shows our house in the state that my parents first purchased it. Weeds that came up to my head (three feet, one inch, incidentally) made up the front yard and lined a dirt ditch, driveway, and road. The down payment for the ranch house five miles outside Helena cost $4,000; in 1982, it was what they could afford.

They purchased the house a year before I was born, in the midst of a run of family disasters. Mom's sister, Mickey, had been diagnosed with brain cancer; by the time of my mom's pregnancy, she had become terminally ill. A single mother with four kids, she asked my mom to take custody of her children. She died in March when Mom was four months pregnant with me.

Even before Mickey passed away, Mom had started attending court hearings to decide who was to get custody of Mickey's children: my parents or Mickey's ex-husband. As my mom's stomach grew, so did the question of whether she would be caring for one child or five.

As Mom split her time between court and visits to her sister in the nursing home, her father was diagnosed with prostate cancer. Shortly thereafter, her mother was diagnosed with skin cancer. It seemed impossible to have this much bad luck all at once.

Recalling all this, Mom pauses for a moment. I imagine her

sitting in the living room with blue carpet under her feet. The smell of water and rotting wood emanating from the kitchen. The sound of Dad's television upstairs. Our golden retriever, Tuck, in the entryway. Frost on the windows and the dim light of sixty-watt bulbs filling the interior. Lining up her thoughts before letting them all out in one rushed breath. I finally hear her exhale, slowly.

"There were two sides to this stretch of time. My personality is pretty resilient, but there was so much going on: my mom and dad getting cancer, Mickey dying, fighting for her kids . . . it was hard not to get down. The one positive in all of this was my pregnancy. We'd been married for three years, and your dad and I really wanted a baby. So we were leaning pretty heavily on the excitement of having our first kid."

I listen on the other end of the line, knowing how the story ends, thinking about the crisis my birth must have been.

The final surprise began on August 17 around six in the morning. Sleeping in their old waterbed, my mom woke up in a puddle, her nightgown drenched.

"Brian, I think the bed broke!" she cried, shaking him awake.

"Marie, I don't think it's the bed."

Two weeks before I was due, Mom's water had broken. An hour later, they were at the local hospital. Their doctor was on vacation, and Mom's parents were in Utah for cancer treatment.

After twelve hours, Mom was still waiting for her first contractions, so the doctors decided to try to induce the birth. Loaded up on Pitocin, a drug that jump-started a series of painful contractions, Mom went into hard labor around seven that night. Three hours later, I still hadn't come out, and Dad began to get excited.

"Hold on! A couple more hours and you can have him on your birthday!"

Indeed, the hours inched along, and Mom's labor continued past the midnight mark. On August 18, I was born. She turned twenty-eight; I turned zero.

I don't really like this bit. It's awkward asking my mom what those first few moments of having a legless kid were like. She must have wondered what kind of life her child would have. I can hear the tension in her voice as she tiptoes around the answer.

"Kevin, you were an exclamation point on a really tough couple of years."

The rest of the phone conversation comes between pauses, white noise between the sighed-out details.

"I could tell from the look on the nurses' faces that something was wrong. I hadn't heard you cry. So I started asking, 'Is he crying? Is everything okay?'"

"The doctor looked over at me and said, 'He doesn't have any legs.' I told him, 'That's not very funny.' He said, 'I'm not joking.'"

Silence, as she collects her thoughts.

"The doctors handed you over after that. You were pretty tightly swaddled up in these white hospital blankets. The first thing I did was pull the end of the blanket out so that you looked long enough.

"It was a long process of us becoming comfortable with who you were."

I don't think that I would know what to do if I were to become the father of someone with a disability. At the very least, I'd probably be ashamed and disappointed. Knowing that I'd re-

act this way makes me feel guilty for what my parents had to go through.

I'm not as strong as my parents, I think to myself.

Mom pulls me out of the spiral.

"I remember asking if stress could've caused . . . this. The doctor smiled at me. 'If stress caused it, there'd be babies without legs all over the place.'

"After that, I can't remember what we asked out loud and what we thought inside."

It all boiled down to one basic question, though:

What could we have done to have caused this?

My parents felt that there had to be an explanation; something like this couldn't just happen for no reason. In a way, knowing that a certain drug had been misused, or that there was a problem during my birth, would have been more comforting. At least then this accident would have a cause.

The doctors sent off the placenta for testing. A panel in another state found the pregnancy to be normal and the placenta to be healthy. Mom didn't take or do anything she shouldn't have.

Dad raced home to ring his parents in Connecticut. They originally weren't going to come out for my birth, But once the information reached them about my lack of legs, Grandma and Grandpa hopped the next flight to Montana.

My dad's parents met my mom's at the airport the next day. Already aware of the gravity of the situation, my grandma asked in a solemn tone: "So . . . how are things?"

My mom's father laughed. "Everything's fine as long as you don't sling him over your shoulder, 'cause there's nothing to grab."

While the concern, apprehension, and fear were real, a bit of

black humor helped to loosen the knot of tension. Everyone had his or her own crack.

The doctors: "He'll never be a professional basketball player, but that probably wasn't going to happen anyway."

My dad: "Hell of a birthday present."

Twenty-three years later, even I chime in: "After all that labor? Must've been like climbing forty flights of stairs for half a chocolate bar."

Soon after the tests returned, I was given a label.

"The doctors said it was bilateral amelia. And I asked what that meant," Mom said.

It basically means "no limbs." It's pretty simple. "Treat him like a normal guy, and he'll have a normal life," the doctor told her.

Except "normal life" couldn't really begin yet, since the hospital held me for a week while I was placed under bright lights and tested to see what else could possibly be wrong. To top it off, only my mom and dad were able to hold me—an activity that I'm told grandparents prize highly. Needless to say, the four grandpas and grandmas were getting pretty impatient.

The doctors didn't budge or give an inkling as to how long they expected to keep me in the hospital. Finally, Dad had had enough. There was a house and a sock drawer retrofitted into a crib with my name on it.

"This shit isn't happening anymore," Dad said. "I'm taking him home."

"Well, you can't. The medical proce—"

"I don't give a damn. I'm taking him home. You can figure out the rest."

Two

ADAPTATIONS

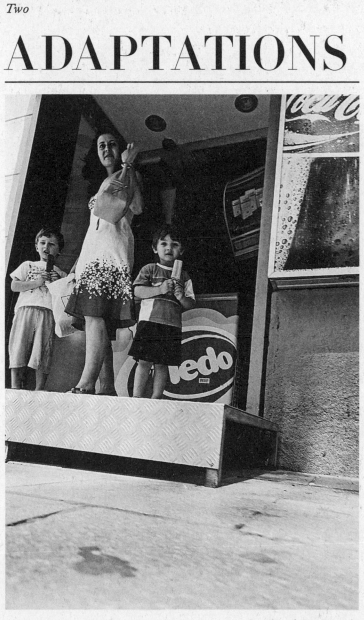

Sarajevo, Bosnia

In *September 1985,* one month after I was born, a television show called *MacGyver* debuted for the first time on national television. Richard Dean Anderson played Angus MacGyver, a former government agent who used ingenuity and improvisation to defeat enemies and get out of whatever tight situation the writers of the show would put him in.

Sporting a feathered mullet, MacGyver would create a new invention in every episode, using only household items. The show ran for seven seasons and featured homemade mortar rounds, lock picks, electromagnets, and an assortment of other inventions. Nearly everyone has heard of, if not seen, *MacGyver,* but few watched it quite like my father.

My dad, also sporting a feathered mullet, was a big fan of the show, and I remember sitting next to him, watching it on the weekends, taking in the smell of beer, Old Spice, and frozen pizza. With the swell of the theme song, Dad would lean forward, take a swig of his beer, and perk up, almost studying the screen for tips.

Since Mom and Dad didn't want to put me in a wheelchair, and books on how to help a legless kid get around didn't exist, *MacGyver* was the best thing going.

During my first couple of years, I ran around outside as

much as possible, using my hands to walk and dragging my butt through the dirt and snow. What my parents saved on shoes, they lost on pants. My mom went to the store and bought whatever was on sale, then spent the whole weekend cutting off the legs and sewing them up. She'd make twelve pairs in a weekend, but I kept burning them out.

By my third year, they began looking for a way to keep my pants and nethers from getting ground to rags and beef. One night, my dad rang up his father in Connecticut and began discussing the problem. Grandpa came to the conclusion that his belt maker might have enough experience with leather to make some sort of shoe. Dad got off the phone and traced the circumference of my butt while I sat on a piece of butcher paper. He promptly sent it to Grandpa.

We got back a formless sack made out of deerskin and held up by a pair of thick red suspenders. Imagine a purse without the zippers, finish, or lipstick, and you get a fairly good idea. My parents called them "leathers," and the name seemed to stick. It reduced the time my mom spent behind the sewing machine and halved the monthly pants bill.

By the show's fourth season, and my fourth year, Dad came up with another invention, his personal favorite: the toilet seat throne.

Since I was too small to sit on the seat, he cut a smaller hole out of the lid and sanded it so I wouldn't get splinters. That way, I could sit on the toilet without falling in. Dad said it was great because he didn't have to pull me out of the john in the middle of the night.

Season five brought safety and navigational inventions.

After I slipped on the stairs and landed on the concrete floor in

the basement, Dad drilled a rail into the wall, close to the steps, so I'd have something to hang on to. The rail not only saved me from future falls, but also kept my two younger sisters, Meagan and Shannon, from taking a tumble to the concrete floor. Mom had given birth to us every two years like clockwork, and while Meagan was reaching the age to become a good playmate, Shannon was still filling diapers and mastering the crawl.

In addition, our old doorknobs were replaced with levers that were easier to open from my height. Strings attached to the levers meant that I didn't have to engage in acrobatics to get out of the basement or bathroom.

Finally, using only scraps of thin plywood and string, Dad built extensions for the light switches so they hung down to my height. A simple yank could turn any light on or off, and with that, my days of fumbling in the dark were over.

Season six, the lowest rated of the series, brought house chores.

"The only time you act handicapped is when it comes to work, but we've got you fixed," Dad said, smirking, one day as Mom brought in a Black & Decker hand vacuum. Up to that point, my only chore was washing dishes, an activity that also doubled as a way to force me into my prosthetic legs so that I could reach the sink. I had been unable to use our old upright vacuum, but during a moment of much-reviled genius while walking through the local department store, Mom had bought the easy-to-use hand-held version.

Every Monday, Wednesday, and Friday was my assigned day to clean the carpets. Within the first week I'd figured out that if I pressed really hard on the machine, I would burn out the motor and be able to slide out of work. However, I did not anticipate

the standard fourteen-day return policy. After that, it became a battle of wills. I'd burn out a new vacuum as fast as I could, then watch my parents race to the store to get the item in before the two-week mark. The man at the customer service counter grew more confused with each return.

By season seven, *MacGyver*'s last, most of the adaptations I needed for basic living had been sorted out, and Dad moved on to other television programs. Some of my logistical difficulties had been erased through Dad's ingenuity, but both my parents knew that someday I'd have to learn how to adapt to life on my own terms, rather than rely on them. So they began to force me into figuring out problems for myself.

How was I going to get up onto a counter if I couldn't be lifted?

How was I going to get across a parking lot in ten inches of snow if I couldn't be carried?

Those quandaries, which for years had been filling my parents' minds, were beginning to get passed along to me. I still didn't have all the answers, but at least I was beginning to figure out how I could fit into a world that wasn't adapted for a person without legs.

Three

WHAT IF?

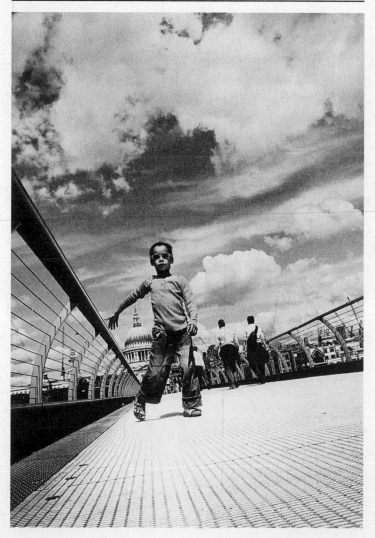

London, England

ool didn't even begin to describe these bad boy Reeboks. The white high-tops had black streaks that wrapped around from the back and streamed toward the toes. The tread was comprised of black ribbed coils that interlaced themselves across the bottom of the shoe. The design looked almost extraterrestrial. These were one-of-a-kind shoes. *My* shoes.

I wanted something that would make my friends and cousins go "Whoa." My parents wanted a pair with large, flat soles that would provide solid balance when they became affixed to prosthetic legs. My limbs were courtesy of Shriners Hospital in Spokane, Washington, which we visited every six months and which provided free medical care and prosthetics for children.

The doctors and staff were nice enough and had always tried to keep me as entertained as possible during each visit to the hospital, but no amount of toys or smiles could hold my patience for longer than a couple of hours in that place, and I was practically bursting from excitement by the time we'd arrived at the shoe store. The doctors were just beginning to construct my prosthetic legs, and they had given us the feet ahead of time, so we could go shoe shopping.

"Mom, check these out! Look at the red lights! My friend has these; when you step, the heel goes *pieu pieu pieu!*"

"Maybe," Mom said, frowning at the price tag. "Why don't you keep looking?"

I was more than happy to oblige and quickly pulled out another pair—almost as cool as the last.

"Look at these!"

"Those'll work, Kev," Dad said, nodding toward the most recent pair I was swinging below his face.

I had seen kids wearing the newest shoes featuring pumps, lights, and add-ons that mine didn't have, and I desperately wanted a pair of my own. I wasn't old enough to realize the inherent difference between my friends and me, nor would I have really cared. The important thing was that all of the cool kids had these shoes. Now, as I held up the one item that could grant me that status, I smiled widely.

My new feet were bigger than the average four-year-old's— a fact of which I was quite proud—and the gargantuan pieces of footwear rested heavily in my small hands. My dad was the one who told me about my foot size (I wouldn't have known otherwise) as he held the beige plasticized object in his hands. That disembodied foot represented something much larger to me—half a body, even.

I had to hand it to footwear companies: you know your marketing is solid when you can get a no-legged kid excited about buying a new pair of sneakers.

Back in the car, I took the shoes out of their box. The laces tangled in my hands as I tried to make the same knot I'd seen everyone else do. No matter how hard I tried, I couldn't figure it out.

"I don't get it," I said, looking up from the backseat.

Mom's voice cracked a little as she twisted toward me, brown hair falling in her face as she tried once more to explain the complex procedure.

"You have to make a little loop with one thumb. And then with your other thumb and finger, wrap the shoelace around the loop . . . hand over the string to the first thumb and forefinger. Pull that loop through, and you make a bow." She held up one of the new shoes to demonstrate, but my eyes glazed over under the verbal deluge of fingers and loops.

I tried again. And again. Each time, my hands fumbled, and I would become impatient. I didn't see the point of learning to tie such a specific knot that I would use only a handful of times in my life, so I gave up. The laces dangled about my wrists as I stuck the shoes on my hands and began making sound effects for footsteps as I pedaled them across the backseat. I probably should have persevered, considering that I still can't tie a shoe to save my life.

When we pulled up to the hospital—an ancient, stone-walled structure on the southwest end of Spokane—I was already white-knuckling the sneaks. Mom and Dad had kept telling me while we were shopping that I would have to give them to the doctors so they could mold my prosthetics to the arch of the soles. But when the time came to hand them over, none of that mattered. I had just obtained my heart's desire, and now it was being taken away. It was on par with getting an action figure for Christmas, only to find that Santa had given it to you on loan. I was upset, but they eventually wrestled the shoes away from me and handed them over to the nurse.

Later that afternoon, our silver Honda chugged up Mul-

lan Pass overlooking the densely wooded forests on the Montana border. We were finally headed home. At any other time, I would have been excited to be returning. Instead, every mile closer to home was farther from my prize.

I sat in the backseat, trying to burn a hole in my parents' heads with my glare. I couldn't believe that they had just taken my shoes. Hours later, I still seethed.

I didn't even want the legs. I just wanted my shoes back.

Mom and Dad decided to stop for lunch and chose a McDonald's a few miles off the highway. Since this particular McDonald's had a Playland, they thought it might draw me out of my sulk. Meagan's gangly two-year-old body was still twitching beside me in the midst of her third nap that day.

My surliness evaporated when we pulled into the parking lot, and I began shaking Meg awake, trying to expedite our getting out of the car. She grumbled until I whispered to her, cupping my hand to the side of her head.

"Meg, we're at McDonald's!"

"Aayyyyiiieeeee!" she screamed in excitement as her posture snapped to a rigid ninety degrees. Mom and Dad quietly winced up front. We had spotted the brightly colored monstrosity that sat behind the windows of the restaurant. Sprouting slides and curved, navigable tubes, the Playland was a recreation mecca for almost any kid whose voice had yet to crack. We were vibrating in our seats by the time Dad kicked the car into park.

"It's packed," he groaned, killing the engine.

Inside, more than a dozen kids were bouncing around, celebrating a birthday. Burger cartons and wrappers poked up from the horizon line of the tables.

As we entered the restaurant, Mom went to put in our order, while Dad found a place to sit.

"Hey, guys, if you want to play, you should do it now before all of those older kids get in there. Fifteen minutes, okay?"

We both eagerly nodded, not registering a word he said.

After helping us open the heavily weather-stripped door, Dad cut us loose. Meg and I swam through the moat of plastic balls that encircled Playland in search of the entrance. Our objective was clear: get in, exhaust ourselves, and get out before the place was swarmed with sugar-hyped birthday goers.

I could scramble through the Crayola-colored pipes faster than most; my pants crackled from static as they swished through the tube behind me, pulled by my calloused hands. The faster I went, the more the static would build and burst around me. After making a few laps through the tubing, I found the slide and jumped in, enjoying one final ride before coming to a stop on the open-faced tongue at the bottom.

Below me sat four pairs of shoes, really cool ones that only big kids had. I thought of my own that probably were sitting on someone's desk a hundred miles away. Four ten-year-old kids sprouted from these vibrant sneakers, all of them wearing conical party hats, all of their jaws slack. Even though I was still sitting on the slide, they were taller than I was.

"Why don't you have legs?"

I shrugged, not knowing or caring what the answer was.

"'Scuse me," I said, hopping off the edge of the slide and squeezing past them.

I began running around to find the entrance so I could make another lap through the tubes. The kids began following me, their questions turning to statements.

"You don't have legs."

I had made it around the structure and found an entrance as their statements turned to exclamations.

"You don't have legs!"

The world flushed red as I entered the cherry-colored tube for the third time that afternoon. As I shimmied through, I could hear their loud alarms rattling up the cylinder and into my ears.

"Hey, guys, he doesn't have legs!" I heard bodies running through the nearby ball pit to investigate, their screams muffled through the claustrophobic plastic walls.

The world kept turning red, then blue, then yellow as I hurried through the tubes, the colors saturating my skin. I ignored the other kids as best I could, but I couldn't understand why my leglessness was a big deal to them. I just knew that I was embarrassed, and suddenly I didn't want to play anymore.

I waited at the top of the slide until most of the kids were in the tubes searching for me before I made my break. I heard a cacophony of approaching bodies and dove down the chute. When I got back to our table, I was crying, but I didn't know why. Meagan was already there, eating her burger. She'd had enough of the play place, as well.

"That's it. Let's go," Dad said.

Mom stayed behind to pack up the food, while Dad led Meg and me out of the restaurant.

"Grin and bear it, bud," he said, holding the door for me.

As I waited for Dad to unlock the car, I looked back and saw Mom still inside, talking to a couple of parents in the restaurant, her neck extended. When we piled into the car and the doors clicked shut, we began to feel a bit better.

Mom and Dad were still fuming about the incident; a good chunk of quiet filled the car long after it found the highway. Meagan fell asleep next to me, while I sat in the back, tired and sad. It wasn't until Dad was swinging the wheels through the canyon that we began to talk again.

"Kev?" Mom asked, her head twisting so her eyes could make contact with mine. She smiled. "Let's play a game."

"Um, okay," I answered, searching through my bag for rogue french fries.

"What if kids started saying that you don't have legs when you start school?"

"I don't know."

Mom paused, gathering her thoughts before changing the tactic.

"Well *what if* they keep saying that you don't have legs?"

I looked up, and suddenly it clicked. The game had begun.

"I grin and bear it," I said.

"Okay," she replied, "you could do that, and it would work sometimes. But sometimes they might not stop."

"Then I tell them to shut up."

"Well, you could do that, too, but you might not make many friends because it will make you seem as rude as they are."

The rules to "What If" were simple. At the beginning of every game, a hypothetical scenario was thrown out, and I tried to field the answer.

"What if you look up in the grocery store, and I'm not there?"

"What if someone starts beating on you on the playground?"

And, of course, "What if someone comes up to you and says, 'You don't have legs'?"

It was by far the hardest question to answer because it was so simple. *Of course* I didn't have legs, but simply responding with "Yeah, you're right" lacked panache. I needed something that would defuse further ridicule or questions.

We played for months, and with each game, my answers snapped out faster. I loved to play because I never lost. No matter what my answer was, I was never told that it was wrong or invalid.

Mom's game was an impromptu class in causality, teaching me the effect of my actions or reactions to any given situation. As my first year of school approached, I had already heard and responded to most of the situations that could present themselves over the ensuing months.

I could switch roles, as well, fielding hypothetical scenarios to Mom about things I thought might happen at school. As I exhausted the practical questions, my head began to cook up more compelling scenarios, the sort that only four-year-old boys would know the answer to.

"What if two robbers break into the school and start hurting people?"

"Well, I don't know about th—"

"*I* know. I'd go find a sword and fight them until they ran away and died!"

The game continued right up to the first day of kindergarten. By that point, my stories had become so ridiculous—and gruesome—that they were overwhelmed by blood-and-viscera-filled descriptions. The game began to mutate from lessons in causality to lessons in storytelling.

Still, we continued to play. Occasionally we returned to the

one question that was always the most elusive in terms of a solid response.

"What if a kid comes up and says that you don't have any legs?"

About a month later, school started. A month after that, my shoes finally showed up. This time they were attached to feet that I was told were mine. I didn't like the prosthetic legs, but at least they gave me a suitable answer to the "no legs" question that had plagued me for so long.

"Yeah, I do, I just don't wear them all the time."

Every ensuing year I was fitted for new prosthetics to wear, and every year I'd whine and grumble about them. Their functionality was poor, at best, requiring me to wear crutches and haul around these two artificial limbs that collectively weighed more than the rest of me. Lacking practical purpose, the only reason for me to wear the legs was aesthetic. The doctors in Spokane wanted me to look normal, even if I had to be virtually stationary to do so.

Ultimately, the doctors knew as well as I did that my life with prosthetics was limited, and they slowly began to request fewer and fewer visits. I had two choices: I could choose the prosthetics in the interest of appearing normal and maybe having a better chance of avoiding the stares that followed me everywhere, or, with my parents' help, I could come up with a more practical mode of transportation.

PLAYGROUND

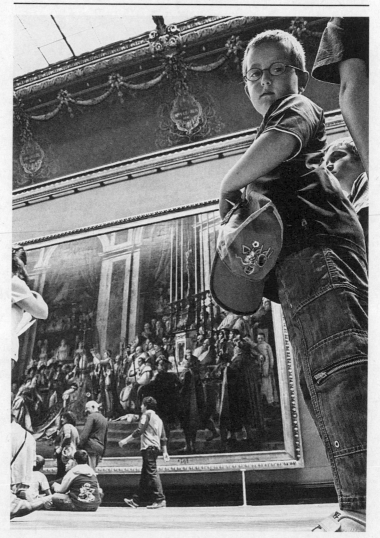

Paris, France

The small, *tinted* windows of the boy's bathroom at Radley School turned everything a greasy shade of sea foam green. It certainly didn't add to the attractiveness of the facilities, but it did provide one of the few places where you could write notes in private, away from the eyes of Ms. Dartman, my fourth-grade teacher. Sitting on the floor, I kept an ear to the door as I clicked my mechanical pencil for a bit more graphite. I used my new wheelchair as an impromptu writing surface, but my pencil kept slipping into the patterned divots that formed the seat, ruining my careful penmanship.

My hands were clammy as I nervously spilled out the preamble to my proposal, detailing the reasons why I was a good choice for a boyfriend. I told Julia that I was really smart; that I was devotedly interested in her; and that, despite being in a wheelchair, I was still pretty cool.

By the end of third grade, I had given up on using my prosthetic legs, only strapping them on upon threat of death or extra chores around the house. They simply weren't a practical way to get around. I *did* want to look like everyone else, but glorified, flesh-colored stilts weren't the solution. Not only did they look artificial, but I had to use crutches to lurch around from place to place.

My parents were reluctant at first to let me give up on the legs, but while they continued to order new sets until I was twelve, they grudgingly conceded my switch to the wheelchair. When we went to the wheelchair shop, a sterile place smelling of latex and molded plastic, I got to pick out the color for the aluminum tubes that supported the black canvas seat.

I began bringing my wheelchair to school in the fourth grade. We had just started switching rooms for different classes, and the chair kept me off the ground when the other students flooded the hallways.

But for all of the wheelchair's practicality, it brought about the first realization that I was disabled. Until then, I'd just been legless, but suddenly I looked like all of the other disabled people that I'd seen in hospitals. A wheelchair has a very specific connotation. Up till that point, I knew that I was considered different from other kids, but only so far as not having legs. Suddenly, when I was in a wheelchair, I was labeled "handicapped." This term was new to me, and I didn't particularly like how it sounded, or the stigma attached to it.

This new image came at a particularly tough point in school, as our fourth-grade classrooms bordered those of the middle school kids. Suddenly, a fair number of the friends I'd grown up with were trying to impress the older kids next door. Many began migrating toward the outer reaches of the playground for quick games of basketball and football. This resulted in ousting some of the kids who were different or unpopular— including me.

What I didn't know at the time was that my younger sister, Meagan, was fighting battles on my behalf. Two years below me,

she was a second grader who, due to an early growth spurt, was the size of some third graders.

Her legs looked like those of a foal, her knobby knees sticking out beyond the skinny thighs and calves that sandwiched them. She was much more assertive and confrontational than I, and as I found out years later, she regularly dished out harsh physical punishment to anyone she thought was making fun of me. Knowing that I'd be embarrassed by the fact that she was acting as a one-girl security force, she kept her operations secret from both me and my parents.

On the playground, Meagan walked behind me to catch the boys who mocked me. When one kid called me a "little douche," she kicked him where it would do the most damage. She knew they wouldn't listen to a second grader telling them to stop, so she used force. Meagan spent a number of years walking around with her fists clenched, always on the lookout for trouble.

Radley School accommodated grades one through eight at the time, so there was a motley group of kids ages six to fourteen, all vying for their own turf. Who got what and who went where was a complicated formula that depended on variables of age, physical ability, number of friends, and the elusive X factor of "coolness."

The sandpit, inhabited by slides, jungle gyms, and tire swings, was the safest place on the playground, because of its proximity to the constantly patrolling teachers. The basketball courts held a mix of ages, with the younger kids being chased off by the older students at recess.

Beyond the courts was a massive, semicircular dirt track surrounding a barren yellow field. The vast piece of land was a law-

less territory, where only the length of your stride and the speed of your sprint mattered. Separating the playground field from the empty meadows curling out for miles beyond was a six-foot chain-link fence.

It had been two days since I'd written my note, and I was still waiting to hear back from Julia. Finally at recess, my anticipation had reached stomach-cramping proportions, and I began the timid roll down the asphalt and onto the edges of the basketball courts, where kids had just started a game. Julia was standing near her friend Hannah, toward the middle of the courts. I sat there for a minute, trying to plot the smoothest way to approach her.

Do I go to the other end and approach her head-on, or come up alongside to surprise her? I wondered, rolling back and forth nervously.

Suddenly something smacked me in the face. The basketball hadn't been inflated in months, and it dropped flatly to the ground. I picked it up and squeezed it, removing the indentation my head had left in its surface.

"Hey, retard! Give the ball back," yelled Trevor, one of the bigger kids in my class. Trevor had taunted me before, but never physically. Laughing, he spun around to face his friends and walked backward over to me, dragging the heels of his sneakers. He had fashionably baggy jeans that smelled like cigarette smoke and a cocky swagger that was in full force as he turned again, facing me. As he sauntered closer, his smile dropped, and his head began to make a restless, bobbing movement.

"Here!" I huffed out. I threw the ball back at his chest as hard as I could, hoping to score some points for bravery. It wasn't the most diplomatic of moves, but I knew that Trevor already had

his mind set on whatever was coming. He caught the ball and threw it away as he kept getting closer.

"What! What! What!" he yelled, slapping his chest with both hands, as we'd all seen the older kids do.

"Nothing!" I shouted.

But Trevor kept coming. Reaching the front of my chair, he swung his fist in a wide arc. It connected just below my ear with a thwack, his knuckles uncurling and flopping open upon impact.

The first hit seemed to fuel his prepubescent blood lust, and he swung at me again and again with increasing zeal. As his enthusiasm grew, he began to dance around me, his arm like an automated sprinkler trying to blast anything within his radius, huffing "You-suck, you-suck, you-suck!" in concert with his swings.

I tried to throw punches in return, but it was futile. I kept pulling back on the rim of my wheelchair with my left hand, while feebly trying to throw retaliating blows with my right. I knew that trying to spin a wheelchair while generating any sort of damaging force toward an opponent was impossible, but I thought that if I at least tried, I might maintain some sort of dignity among the kids who'd gathered to watch.

I couldn't spin fast enough to keep up with Trevor, though, and he quickly maneuvered himself behind me. His hits became faster and more precise. I felt a blow connect with the nape of my neck, then another on my left ear. Then one glanced off the right side of my head as he opened his hand, clumsily clawing my face with his nails in the process. The blows kept coming, and by the time one caught me just behind the jaw, I'd stopped spinning. My resolve had started to crumble on this whole "at least try to fight back" thing. I realized that in my wheelchair, I

probably looked even less cool trying to retaliate than I would by just clamping down and taking it.

So I stopped spinning. Another half-dozen hits slapped my head as Trevor kept swinging, but by that point I'd given up. I slouched down in my seat and hunched my shoulders, waiting for him to run out of steam. I focused my gaze on the rough blacktop, its uneven surface marred by the cracked white paint of the court lines.

When I looked up in between blows, I saw Julia standing in the crowd. Who knew where my notebook paper missive had gone, but I still wanted to show that I was tough—or at least as tough as anyone could be in that situation. I tried to make my neck rigid so my head wouldn't jerk with Trevor's hits. When I finally made eye contact with Julia, she had shuffled slightly closer to Hannah. Both of their faces were squished into frightened winces.

I don't remember consciously deciding to smile, but nevertheless a thin-lipped grin plastered itself across my face. Maybe it was my last-ditch attempt to impress her, to make her uncrumple the note probably crushed at the bottom of her backpack. Maybe it came about from a lack of better options, a somewhat futile effort to override the hopelessness of the situation. Needless to say, she didn't smile back.

When the beating stopped, I looked up at Trevor. He was standing there with his hands at his sides, gasping from the effort. His faced was flushed, and he was sobbing, occasionally choking out a "you suck" between sniffles. He appeared to be more traumatized than I was. We remained there for a moment, staring at each other, then he turned away and ran into the vast empty stretches of the yellow playing field.

It felt almost worse watching him leave than taking the beating. I knew that not only had I lost the fight, but I probably looked like an idiot trying to ignore the fact that I was getting pummeled. Judging by Julia's face, it had been obvious to everyone else.

Of all the things, why the hell did I smile? Why didn't I get out of my wheelchair and punch back? Why didn't I yell out or curse? I berated myself as I rolled back into the building. It never occurred to me that I should have been questioning Trevor's motives instead. I guess that, at the time, it seemed obvious to me that I was different since I was in a wheelchair, and thus fair game.

When I came back into the classroom, my teacher looked up from her desk and came rushing over. I mumbled, "I'm okay," before she could ask what was wrong. I sat in her room for the remainder of recess, working on a drawing of soldiers and explosions, imagining myself on the winning side of a stick-figured battle. I never mentioned the fight to my parents, and if Meagan ever heard about it, she never let on.

When the rest of the kids came back inside, one of Julia's girlfriends skipped over and dropped my tightly folded note on the desk. I looked up as she smiled and walked back to her seat. Written on the second sheet were a couple of sentences neatly printed in pink gel pen. Julia's handwriting was girlish and bulbous, with little circles drawn above the lowercase i's. The first two words were "I'm sorry," and everything that followed was devoted to making sure I understood we'd never be boyfriend and girlfriend.

Following that afternoon, I started spending more and more recesses inside. Sometimes I'd bring a friend with me to play cards or draw, but I avoided going outdoors as much as possible.

When the teachers forced me to, I'd stick close to the building, opting to play Pogs and card games with a couple of my close friends.

For the most part after that, things were pretty good. My teachers were amenable to my staying inside, and I never got another beating after the one delivered by Trevor. Despite that, I would spend most weekdays wishing I was far away from school.

STANDARD ISSUE

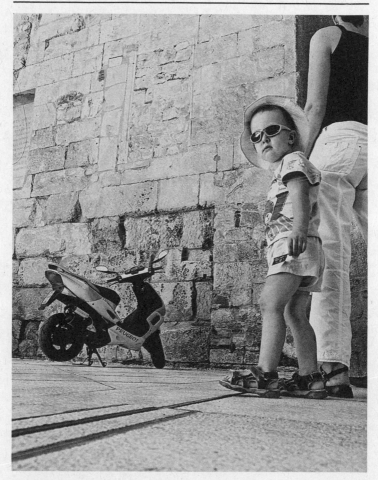

Split, Croatia

As I walked out of the locker room for my last match of the tournament and into the gym filled with screaming parents, I looked over and saw my opponent. He and the ref were standing on the mat, waiting for me.

I can probably take him, I thought.

The odds even seemed a little stacked in my favor, because though we were both ten and in the same weight class, my upper body strength had developed far beyond my age. You don't really need the pubescent boost of testosterone to develop muscles when you're walking on your arms every day.

As soon as I stepped onto the blue mat, I actually began to feel a small sense of bravado. Unlike most of the wiry wrestlers at the tournament, I had pecs. And biceps. And though I didn't know what they were, my coach had even told me that I had "strong traps."

As I waited for the whistle to blow, I looked across the ring at my opponent. He looked as if he'd been stretched—like a kid who had yet to possess his newly acquired height. As the ref moved between us, I saw him lift his leg, shake it, and repeat the process on the other side. I mimicked him with my arms, trying to feign a well-rehearsed ritual.

The whistle blew, and I rushed him, trying to wrap my arms

around his knees. Instead, I got a dull knock to the head as he threw out his palm, his hand heavily connecting with my forehead and stopping my advance. It didn't take long after initial contact. Within seconds, the boy rushed in for a tackle. He was twice my height and came down on me like a sack of scrawny, well-placed bricks.

My chubby face was being dispersed across the mat as my opponent's forearm pressed into the base of my skull. I could hear his breathing and feel mine, as I sucked in the familiar smell of the cleaning fluid they had sprayed on the mats. Working against his every ounce, I started to haul myself off the floor. I thought that I was finally going to beat this leverage thing when the kid pulled me up and threw me onto my back. I landed with a thud, the wind squeezing out of my chest.

The ref's whistle blew in my ear as I let the gym lights burn a hole into my eyes. I thought of all that practice; those nights of running laps and trying to keep up with the other kids; all those nights pummeling my hands into the gym floor—all of it just to be thrown on my back in less than a minute.

I wasn't supposed to use the word at that age, but it cycled through my head anyway:

This sucks.

I sat up and moved beside the ref and the victor, my eyes glued to the ground and the dark splash of sweat that stained the mat a foot or two away. I had all these totally sweet pecs, bis, and traps, but none of them offered much help to someone lacking the leverage that long legs provided.

My parents' friends all had kids of their own who played team sports, mostly football. Dinner parties were usually on the weekend, after the Pee Wee football league games were fin-

ished. My friends would show up talking about tight end positions and their favorite NFL guys, grass stains still on their pants. I wanted in.

But my desire to play football wasn't really for the game itself. I wanted to fit in, and in Montana, playing school sports was one of the few ways to do it. What we lacked in theaters, libraries, and museums, we made up for in mountains and fields. So to be one of the few kids sitting outside the circle of athletics was rough.

I tried to keep up appearances and made every effort to seem interested in sports without actually getting to play. I watched football on television some nights so I could talk about my favorite team at school. I convinced my parents to buy one of the starter jackets that were considered de rigueur at the time. It was a 49ers' windbreaker with gold lettering that had as much water resistance as a couple sheets of toilet paper. I even attended quite a few games—if, for nothing else, to be seen at the same events as my friends.

Trying to roll a wheelchair across the thick grass of a football field is surprisingly difficult, and I struggled to keep pace with my father as we slogged down to the bleachers. Dad, normally a fast walker, shortened his strides so that I could keep up. He always made light of the situation, never hesitating to give me a bit of a hard time.

As I learned later, it made him feel bad to see me sit on the sidelines while his buddies' kids were out on the field. He knew that I wanted to go out there and play, but I had a tough time just getting to the cheering section. He could see that I thought being on a team would be great, but I couldn't figure out how to do it. And he was concerned that I'd get banged up if I tried football.

Admittedly, he was right. I knew that I wasn't fast enough, and at best, all I was going to get would be a truckload of physical abuse from inevitably being at the bottom of a dog pile at the end of every play. At worst, I'd suit up and practice, just to sit on the bench every game.

Then one day I saw a poster for the wrestling team at school. Now, here was a sport that would be a much better fit. I didn't have to run or carry a ball, or anything of the sort. Instead, I'd get to use my arms and natural strength to pull kids to the ground. I came home that day with the poster in my backpack, the red construction paper still covered in crumpled masking tape.

After dinner, I made the case to my parents, pointing out the hand-drawn pair of wrestlers grappling in the middle of the poster. Hearing my enthused arguments for joining the team, Dad finally said, "You won't know till you try, I guess." Mom was supportive, as well.

We went to the school gym on a cold Monday night and took our place in the long line of parents and kids. I bounced at my dad's feet in excitement at the thought of getting to wear the standard-issue red T-shirts with the team name on them: the Helena Tigers. To get *anything* "standard issue" was a pretty special deal for me.

Dad told me later that it was tough standing in line. Some people knew us, but some people didn't, and he could see the pitying look in their eyes. The coaches hesitated at first when they saw me, but then said they'd give it a try. So we signed the forms, and I joined the East Helena Wrestling Club as part of their second-level "midget class" division.

The next night was our first practice, and it wasn't long before

I realized how wrong I'd been in my assessment of the sport. I did everything that I could to keep up with my friends and try to fit in with the team. Every Monday, Tuesday, and Thursday, we'd run forty laps. Later I'd come home, my wrists swollen and aching. It was my fault, really. The coaches were incredibly nice and would have adapted to almost anything I needed, except that I needed to conform, and that didn't leave room for individual adaptation.

Some of the kids on the team would encourage me as they passed, but I was usually too fixated on my own incompetence to take comfort from it.

In addition to doing laps, I spent a good amount of time getting pummeled into the mat during practices. While I was strong compared to the other kids, my strength was relegated to two limbs, both of which were easily wrapped. Other kids on the team figured this out pretty quickly and used their height to come at me from above. The other downside was the fact that my face was right at knee level to most of my opponents. Once or twice a week, I'd come home with a swollen cheek or knot on the head from an errant knee. The look complemented my wrists nicely.

I tried to be a tough guy when Mom or Dad came to pick me up from practice. It didn't work very well, though, as my face usually was still red from kissing the mat. Dad broached the subject before I did.

"You need to finish the season."

"I know."

"I know you know, and I feel bad that you're getting so busted up. But you still need to finish the season."

I realized that he was right, but I was tired of struggling with something at which I only seemed destined to lose.

After my last match of the tournament, Dad and I quickly left the gym and got into the car. Thirty miles down the road, I sat looking out over the radiating emptiness of northern Montana. I had school the next day, and we were racing to get to Helena before darkness fell.

My dad had filmed both of my matches, and I watched the replay through the eyepiece on our VHS camcorder. The back of my wrestling singlet was blue, and the grainy footage bled the line between my body and the mat. The only thing that really stood out was my color-saturated face that burned as I silently struggled. I saw my mouth crack open as I gulped one last lungful of air in preparation for my final push. My muscles didn't look quite as big as I'd imagined them, and the camera shook a little as Dad juggled the duties of cinematographer and cheerleader, screaming from behind the lens.

As I was flipped over, the camera began quickly zooming out. From a distance, I looked like a trout that had just been thrown onto a boat, pathetically flopping and squirming on the deck. There wasn't even the visual drama of wildly kicking limbs. Just a little bit of thrashing, then a whistle that bounced hollowly around the gym.

"Shit," I heard Dad mutter on the tape as the screen clicked into an electronic blue. I looked over at him.

"There's more," Dad said, keeping his eyes on the road. "Your second match should be after that."

I pushed fast-forward, and when I hit the play button, the referee was already whistling for the match to begin. This boy was as scrawny as the last, with straw-colored hair and ribs you could count from the bleachers. Still, he'd seen my previous match and used the same tactic. Rushing forward, his knee ac-

cidentally connected with my head, snapping it back as he, too, fell on top of me. Whistle blown. I was out.

"That last one hurt," I said, staring down into the camera.

"Yeah, looked it," Dad said. "That's it, though. Last tournament and match. You're done. You didn't quit, which is all I care about."

I nodded.

"You know, the coaches told me how impressed they were with you."

The car's defrost fan blared white noise as I turned off the camera.

"Ya know, it's not easy for me, either. No one wants to watch their son get his ass kicked. It's just that they got leverage, and you don't. Maybe this sport ain't for you."

"Yeah, I know," I replied, exhausted.

"Well, I got a couple irons in the fire. You think it'd be fun to go skiing? I got a buddy who was telling me about a place in Bozeman called Eagle Mount that would set us up."

Dad put his foot down a bit further to the floor, coaxing the last bit of juice out of our old van as Highway 287 rolled south into Wolf Creek Canyon. I looked out the window at the towering mountains on either side of us. Each range was covered in ice and snow, and I thought about what it would be like to ride down one.

"Okay," I said.

Six

DIRTBAGS

Big Sky, Montana

It *was cold* at the top of the intermediate, "blue square" ski run at Bridger Bowl. I sat there, slouched under a fleece jester's cap, its formless points drooping over my flushed face. I was looking down at the steepest run I'd yet seen in my four weeks of skiing, and I could feel my elbows beginning to go wobbly as my confidence hitched itself somewhere in my throat.

"Buck, I don't know if I can do this," I said, trying to bargain my way out of the run ahead.

"Well, we're up here now," Buck said, ending the argument.

It had been a year since my days in wrestling, and my third time in a mono-ski under the auspicious guidance of a short, red-haired volunteer named Buck. He was a roofing contractor by day in the nearby town of Bozeman, and on the weekends he had begun volunteering at an adaptive skiing program called Eagle Mount. The nonprofit program specialized in providing sporting lessons and equipment to people with a wide range of mental and physical disabilities. Pressed for his motivations to volunteer, he'd told my dad, "It sounds really corny, but I had so much fun skiing up at Bridger my whole life that I kinda wanted to give it to others."

Buck had been told by an Eagle Mount staff member that I would be "just a toboggan ride," which meant I would be unable

to get around the mountain myself and would instead have to be placed on a tether and physically steered across the terrain. He had been encouraged to keep me restricted to the lower mountain and to make sure I was handled safely.

It bears noting that Buck was a self-described Dirtbag, which he explained on one of the early lift rides up the mountain: "Being a Dirtbag means you don't give a damn about much, aside from skiing, drinking beer, and being outside."

The more extreme the Dirtbag, the more their passions overruled the traditional responsibilities of career and family. But it's really the uniform of a Dirtbag that sets him or her apart from other skiers on the mountain. Imagine someone wearing a pair of five-year-old snow pants held together loosely by half a roll of silver duct tape; a jacket covered in a hearty mixture of snow, spilt beer, and dried blood; and, finally, a tangled beard smeared with ice and crumbs from a half-eaten sandwich still stored in a pocket.

One of the most overarching characteristics of a Dirtbag is a certain nonchalance when it comes to self-preservation. No one—regardless of his or her ability or physical appearance—is handled gently, and after our first day together, the gloves came off. Instead of making me the "toboggan ride" that initially had been proposed, Buck started taking me up higher on the mountain and pushing me off runs that I wasn't supposed to tell my mother about. If I did get hurt, then he might show some concern, but until that bloody threshold was crossed, he never stopped me from doing anything.

"I'm not a coach," he told me as we rode the lift. "I know how to ski, but I'm not the best at teaching someone how to ski. I have no experience teaching someone in your situation. Maybe a

professional instructor would be able to tell you what is danger-
ous or what you shouldn't do. But I don't really know what you
can't do, so I guess we might as well try everything."

Looking down from our floating, elevated chair, "trying ev-
erything" seemed like a great idea. From our vantage point, I
could see the trail options Buck pointed out as we crept up the
mountain. From that height, nothing looked steep, difficult, or
dangerous. But as I quickly learned, there is a major difference
between stating brave claims and actually backing them up. As
the weeks went on, and I got a few wrecks under my belt, my
eyes would narrow in wariness whenever he spoke of his omni-
ski paradigm.

"C'mon, Kev," Dad piped up. "We can't just sit up here. If
you want to keep getting runs in, you have to do this." Dad, who
had been standing quietly behind us, had begun to get impatient.
He gave my bucket a gentle push, sliding me closer to the edge of
the cat track that overlooked the run.

"Just remember what I told you about keeping your shoul-
ders square and reaching for those turns, got it?" Buck crouched
down and pantomimed a turn in a mono-ski.

"Okay," I said, timidly pushing myself onto the top of the
hill. As my ski silently began picking up speed, my last strong-
hold of confidence evaporated. The sepia-tinted world blurred
around me, and a mixture of rushing wind and panicked breath-
ing fogged my goggles.

When learning to ski, there is one very marked difference be-
tween mono-skiing and able-bodied downhill skiing. This dif-
ference boils down to the number of skis under you at any given
moment. A mono-ski, as the name would imply, has only a single
board on which to balance and turn. With able-bodied skiing,

you have one board strapped to each foot, which should—provided you are not a trout, moose, or spider—add up to two.

So, if you were to attend a ski lesson for the first time, your tutor—let's call him "Hans"—would probably tell you about two positions that you must learn, to ensure some amount of self-control on the hill. The first position is called "French Fries," which translates into keeping your skis pointed straight ahead and parallel to one another.

Any decent skier or racer is going to spend ninety-nine percent of their time in the French Fries position, because it allows him or her to gain speed quite quickly. If you've ever seen a professional skier race down the side of a mountain at ninety miles per hour without turning, then you've seen a classic example of the French Fry technique.

Now imagine Hans's deep Austrian voice speaking up: "But you mustn't use ze French Fry for too long, or you vill lose control and endanger your life." This is where the second position becomes important.

Named the "Pizza Pie," this technique should be the first thing that you learn if you are new to skiing. The Pizza Pie is used for slowing yourself down and staying in control. To enter this position, you point the front tips of your skis inward to form a wedge, or, if viewed from above, a slice of pizza.

The Pizza Pie is the yin to the French Fries' yang and is the go-to position should you find yourself gaining too much speed or on the verge of losing control. For all new skiers, the Pizza Pie is how you stop. It's how you stay safe. And, ultimately, it's how you avoid what's coming up next in this story.

But what happens if you are in a mono-ski and are unable to create this Pizza Pie? What if you freeze up out of fear, unable

to stop, but too afraid to fall over? Well, then you become a very fast freakin' French Fry.

As my single track careened through the snow and gained momentum, the ski began to bounce over some of the larger bumps in the hill. I tried to turn but couldn't remember how. I knew that there was only one way this situation could end, and when the downhill edge of the ski caught in the snow, I relaxed, knowing that my fate was sealed.

The world started to spin as I entered nature's tumble cycle. Then, as the ski began its third flip, centrifugal force pulled me from the fiberglass bucket which, until that moment, had held me loosely in place. But "loosely" was the operative word, as the only form of securing the rider was a series of nylon straps meant to tighten around my legs and lap. Considering that I lacked both of the required parts, the nylon rolled around flaccidly as I launched from my bucket and turned into a meaty, eleven-year-old ballistic quickly gaining elevation as the snow blurred white beneath me.

As I rose into the air, the bright green and red flaps of my jester's cap streamed behind the shoulders of my snowy 49ers' coat, and I began to resemble the colorful garbage that comes out of a New Year's party popper.

As my flailing body hit the apex of its trajectory, I experienced a moment of tranquility. I wondered why I had chosen to leave the comforts of a warm wrestling mat. I wondered why I had signed up for skiing in the first place. And I wondered if the inspirational quote at the bottom of the enrollment form, "...*They shall mount up with wings as eagles,*" was simply an advertisement for the fix I currently found myself in.

Festive as it was, my jester's cap was not at all suited to handle

heavy impacts—a fact that proved true as my head pioneered a crater into the ski run. The leftover energy from the crash immediately propelled me back up into the air.

As I bounced my way down and into the hill, something odd happened. I started to have a little bit of fun. Sure, my head had just sustained a severe impact, but nevertheless I had a smile on my face as I finally slid to a stop.

My clothing had been rearranged by the hits, and every open pocket or crevice had filled with snow. My face had gotten pretty scratched up from the ice, and my arms were burning from repeated attempts to cushion my landings.

I felt a mist of snow across my face and looked over to see Buck edging to a stop nearby.

"So what do you think you did wrong?" he asked, clicking his boots out of their skis.

"Landed on my head," I said, my skull beginning to fill with cotton.

He hesitated, a flick of concern sliding across his face. "You also caught an edge, which is what probably flipped you over."

Buck took a couple of steps uphill, preparing for a demonstration.

"You see what I'm doing?" he asked as he squared his shoulders and leaned his hip slightly back. "You need to try and do something like this when you're in your mono-ski. Remember, or you're gonna keep taking those hits."

Buck looked over his shoulder to see my dad nervously trying to make his way down the hill. His arms were stretched out, trying in vain to grab hold of the air in order to slow himself down. He had forsaken the use of ski poles on account of their being

"distracting," though, as I watched his arms thrash about, I wondered if this alternative was any better. As he neared, I could see that his woolen hunting pants and old blue windbreaker were covered in patches of white from a previous fall.

"I almost worry more about your dad than anything," Buck said as I began pulling fistfuls of snow out of the front pocket of my coat. He turned and began hiking back toward my mono-ski, which had buried itself about ten yards uphill.

As Dad reached us, he boomed between gasps, "Good one! You must've gone twenty or thirty feet!"

"Really?"

"Yeah, you went pretty far," Buck said as he returned with the heavy ski slung over his shoulder. "Hey, can you look at me for a second?"

I tried to focus my eyes on his as he squinted. "You got hit good, didn't ya? Your pupils are looking pretty dilated."

"Can I still ski?"

Buck frowned, looking down toward the ice.

"Will you tell Mom?" Dad piped in, a fatherly tone edging into his voice.

"No." I shook my head, increasing my dizziness.

Buck dropped the heavy ski off his shoulder.

"All right, then get back in."

While we skied out the rest of the day, a knot began to develop on the back of my head. As we made the two-hour drive home that night, Dad kept shaking me every ten minutes.

"I don't want you falling asleep if you've got a concussion. Remember, don't tell your mom, okay?"

"Yup," I said, languidly watching the mile markers zip past.

"So what do you think?" Dad asked.

"About skiing?"

"About Buck. He's good stuff. I think this'll be good for you."

Aside from my head injury (and the half dozen I would incur in the years to come), he was right. It was good to have someone who was unperturbed by the fact you were a legless guy and only interested in getting you on the hill to ski. Buck asked the same of me that he asked of everyone else; as long as I didn't whine or complain, we'd keep skiing.

"Yeah, he's cool," I replied.

When we trundled into the house late that night, our bodies still damp from sweat and snow, I vowed to keep silent about the concussion. Still, judging by the look Mom shot Dad as my first wobbly words rolled off my tongue, she knew.

"Go have a seat. I'll heat up some leftovers."

The next week we showed up at the hill to see Buck holding a knotted cluster of black straps and buckles. It was a shoulder harness that would connect to my ski and keep me from flying out, in the event of another wreck.

"That should keep you from making craters in the run again."

After the previous week's crash, Buck had gone home and MacGyvered his own invention to keep me from becoming a human projectile. He'd taken the time out of his normal workweek to make sure that I could keep skiing. But his presentation of the strap wasn't ostentatious. There were no hugs or high fives, or beaming smiles. That was not a Dirtbag's way.

When I looked up from the gift, he threw a white Eagle Mount helmet at me.

"And that's in case the shoulder strap doesn't work."

BLIND
SUPPORT

Selce, Croatia

Y ou and your goddamn crab apple trees," Dad muttered to Mom as he huffed across the snow at the base of the ski hill. His eyes were covered by a dark blue bandana, over which was a pair of black aviator sunglasses. He looked like a cross between a pirate and Ray Charles as he trudged toward the finish line for the Giant Slalom at Big Sky Resort, my self-appointed "home hill" just south of Bozeman, Montana.

Eight months earlier, my dad had been blinded by one of my mother's pruned crab apple branches. After putting some new shingles on our roof, he had begun his descent down our old, rickety aluminum ladder. As he turned around to head inside, a sharply chopped branch ripped into his left cornea. The mistake was quick, but the recovery was long. The doctor said that it would take months, if not years, to heal properly.

He'd been told by his doctor not to spend much time in bright light or leave his eye unprotected to sun or dust. He was given an eye patch to strap over the left side of his face and admonished to leave it alone. Dad knew that if he told the doctor he planned to attend his son's weeklong ski racing event, he would have received an enthusiastic "no." The combination of cloudless spring weather and brightly reflective snow would make it difficult to see, even for healthy eyes, and could set back his recovery.

As he reminded me on the ski lift during the first day of the race, "There's a time to go to a doctor and a time not to, and when they're gonna give you a 'no' anyway, then why bother? Better just to do it."

So that's what he did. He was unable to fit snow goggles over his eye patch, so he'd gone without, squinting his one good eye in the Montana sun.

During the first full day of racing, Dad stayed out on the hill, helping course volunteers set the gates for the second day's race. He stayed out with them until well after the sun had dipped behind Lone Peak Mountain, a towering, pyramidal behemoth that comprised the skyline for Big Sky Resort. When he came home that night, already complaining of pain in his right eye, my somewhat frustrated mom couldn't help but speak up.

"Well, why did you stay out there so long if you couldn't wear eye protection?"

"I don't know. The guys on the hill needed help, so I helped them," he said, shrugging.

When I came into the room around seven thirty the next morning, Dad was sitting at the kitchen table of our rented condominium holding a can of beer. His head was bowed, and I could see his eye patch straps stretching underneath the aviators. When he put down the can, I heard the hollow aluminum "thunk" of a drink half-gone.

"What happened to you?" I asked, glancing at Mom as she stood across the room, looking concerned.

Dad raised his head. "I don't know, bud. Tried to open my eyes this morning, and something tore in my bad eye. I think my good eye is snow-blind. Hurts like hell if any light hits either of 'em."

Dad raised his can of beer in salutation as Mom sighed. I plopped myself at the table beside him as Mom brought over a bowl and cereal. I began wolfing down my breakfast; the schedule for the race was tight, and I wanted to be ready to go when the lifts started running at eight thirty.

"So, are you staying home today?" I asked.

"Fuck that. Can't let something like this stop ya, after so much effort. I'll be at the bottom waiting for you. We're at the home hill, baby!"

After my first few years of skiing and learning the ropes with Buck, I began to get the itch to compete, which I relayed to my father regularly in the hopes that some of the itch would wear off on him. There were no sanctioned disabled ski races in Montana at the time, so the request was a complicated one—certainly more complicated than I realized. Every race was held out of state, and in order to remain competitive, you had to attend at least two or three per season.

I don't remember the exact moment when he said "yes," but I do recall being lectured about the responsibilities I had to uphold in exchange for his helping me race. Ski racing entailed missing up to fifty days of school a year, and one of my biggest hurdles was managing any semblance of academic success during the season.

"You gotta keep your grades up. If you're not getting A's, I'm gonna be pissed," he'd scold between sips of beer, "and you won't be skiing anymore."

I'd spend late nights in my room, my work strewn across the foot of my bed in attempts to avoid a loud, fatherly tirade.

"And you'd better get all of your make-up work done before we leave for a race," he'd add.

So the week before Dad and I would leave the state, I'd ask my teachers for any make-up work that I could get my hands on. Thankfully, most of these teachers not only tolerated my extended absences, they actively encouraged me to continue competing. My seventh-grade English teacher took his support one step further. Instead of assigning a pile of generic worksheets, he gave me a black journal with dancing skeletons printed on the cover. "Here. An entry every day. I'll read and comment on it when you get back," he said, handing me the notebook.

In preparation for a trip, we stayed up late the night before, loading the van with ski gear and food for the road. Last of all, I tossed in a thick binder, packed to the gills with homework. Dad drove while I alternated between paperwork and narrating our various trips in the skeleton journal, using the big cooler as a desk.

Unless someone was riding with us—occasionally Buck or another ski racer—my responsibilities in the car were simple: keep a ready supply of Mountain Dew and salami sandwiches on hand to pass forward at Dad's request.

By the time we reached our destination, our van reeked of deli meat, sweat, and stale soda. After a week of skiing and a return trip home, the smell was exacerbated by the half-melted snow that clung to the carpet and seats. The only force mitigating the van's powerful stench was the cold. To keep himself awake on some of the longer drives (for example, a 2,300-mile trip from Helena, Montana, to Mount Snow, Vermont), Dad left the windows down, circulating an icy February gale throughout the car. The snow in the van refroze, and the aroma subsided, at least for a while.

I slept as much as I could during the day so I could stay awake when night came, to ensure that Dad didn't fall asleep at the wheel. Since our budget didn't allow for an extra night at a hotel, we always drove straight through. About nine o'clock, Dad's drink of choice shifted from water to Mountain Dew, which he swigged until morning. We blazed down the interstate, loudly playing mix tapes of Tom Petty, Cream, and John Mellencamp, their vocals stretched and distorted from years of use. It was on those late nights, half-crazed on caffeine and corn syrup, that he'd justify his zeal for these marathon road trips.

"Everybody needs something that they can do really, really well. Something that they can do well enough where everything else doesn't matter as much. For you it's skiing, and for me it's driving, baby."

We drove almost 40,000 miles during my four years of ski racing through middle and high school. During that period, Dad put any thought of a full-time career on hold. To compensate, he worked on any odd job he could find, from roofing and construction to substitute teaching—all of it provided that he could take time off for ski racing.

To finance these trips, Dad talked up anyone who would listen. Corporate sponsorships were out, as there wasn't much benefit to throwing money at a legless kid, so instead Dad collected donations from friends and family. His father, Grandpa John, helped the most. Every year in late autumn, without any fanfare, checks showed up from Grandpa and his friends out East. Money always appeared when we needed it, followed by Dad's command, "You need to write a thank you letter for this."

It's interesting to note that Dad was—and forever will be—an absolutely terrible skier. He was offering up his support with

no knowledge or experience of the sport that I was so deeply involved in. He grew up in the Bronx, and before taking me out for the first time had skied only twice in his life. The learning curve is much steeper for a busted-up, forty-year-old man than for a teenager, and Dad remained upright on the hill only by sheer force of will.

To best describe his skiing "style," you'd have to imagine a basketball player in a defensive stance: feet spread, butt out, legs locked at forty-five degrees, arms splayed in all directions. This position is fine under the bright lights of a basketball court, but when transferred to the top of a slope, it looks like a four-limbed disaster on the cusp of self-destruction.

His fashion sense mirrored his skiing style in its motley chaos. He wore his woolen hunting pants well into the second season. His gloves and coat were always half-trashed hand-me-downs from the previous year. To complete his ensemble, he grew his dirty-gray hair down to his shoulders and topped it all off with an oversized handlebar mustache.

I could tell Mom's opinion of his locks whenever it came time for haircuts. She'd hold the scissors earnestly as she tried to sweet-talk Dad into shearing his mane to a reasonable length. Dad wouldn't have it, though; he'd respond with forced incredulity: "Kev's always getting stared at when we go to these races, and it's bugging both of us. So I figure that if people see this long-haired maniac comin' at 'em first, Kev won't seem so weird in comparison." He'd shrug, the logic seeming obvious.

One night, after her third lost battle on the hair front, Mom came back into the kitchen shaking her head in frustration.

"There's some sort of cracked genius in there, but it's buried *real* deep," she commented, putting the scissors away.

Between his lack of concern for self-preservation and interesting wardrobe choices, Dad quickly gained credibility with the skiing Dirtbags around Bozeman. After becoming close friends with Buck, we were introduced to a whole new crew, guys who didn't have much money but were willing to give their time to help train me, tune skis, or repair equipment. The Dirtbags and my dad shared many life philosophies, to put it mildly.

Some of our relatives and friends had the money to help us, and the Dirtbags had the time. In the middle of it all, Dad operated as a sort of crazed maestro of the whole operation, keeping the funds coming in while finding ways for me to get impromptu coaching on the hill. He kept all of the balls afloat, without ever letting me get wind of how demanding the whole thing was.

I was in my third year of racing when someone decided that Big Sky, Montana, would be the best place to hold the national championships. The league quickly agreed, and soon Dad began planning for the first competition ever to be held close to home, rounding up as many people as possible to attend the race. In the weeks leading up to the event, he grew stressed about finding a place to stay and coming up with the money to bring the family to the mountain for the week.

But as I stood at the top of the Giant Slalom racecourse, I wasn't thinking about Dad or the amount of work he'd done to get me to this spot. Instead, my sixteen-year-old mind was concerned with only one thing: winning the race. It was my first chance to perform in front of local friends and family; after three

years of travel, I was finally going to show them what I'd been doing with all of my time. Finally, this was my show.

So when the buzzer sounded, my thoughts were limited to the next gate and the single ski underneath me. All I wanted was to wind up with a medal around my neck, and a few hours to rest up for the next day of racing.

I was one of the last people to run, and when I hit the midpoint of the course, the snow had begun to turn into mush from the afternoon sun. With so many racers edging their skis around the same gates, a deep trough had developed in the mountainside. As I rounded the final few turns, I was reminded of Olympic bobsledders, trying to hang on for dear life to the rounded, deep walls surrounding them. By the time I crossed the finish line, I was chugging for breath.

When I checked the results board and saw my name slotted at the top, I heaved a sigh of relief. I could hear cheers and yells from the hundred or so people gathered at the bottom; for the first time, I knew most of the throats those noises were coming from.

After some pats on the back and visiting with friends and the other racers, I skied over to the sundeck of a nearby restaurant, where my family had created a base camp by scattering their gear around a couple of tables. I found the nearest one and began the long process of getting out of my mono-ski and skintight racing suit. I finally sloughed it all off and went over to sit down. I was looking up at Lone Peak and wondering when I'd next get to ski up there, when Mom came over.

"Oh, hey. I was just at the finish line, looking for you. I made some sandwiches if you want one."

I nodded as she reached into a cooler. Mom had just begun to

ask if I wanted something else when a loud clamor interrupted her.

Across the patio, Dad had walked into a table and was cursing as he furiously rubbed his right thigh. The blindfold had come partially undone, its bottom drooping past his nose. His face was almost entirely covered by the patterned cloth, the only flourish of humanity his ever-present aviators. By the slurring of his words, it was plain that he'd treated his ocular pain with a steady stream of beer.

I turned to Mom. "How's Dad doing?" I asked, already becoming a little embarrassed.

"Oh, he's doing well. He's reveling."

"Why?"

Mom leaned in toward me. I could tell that she was in her "I'm going to level with you" mode.

"Of all the years and hours he's put in trying to get you to these races, up until now, he's been one of the only ones to see when you do well. He's never gotten to show you off to his friends here in Montana. He's . . . he's just so happy that other people could see you race." She blinked, keeping her eyes closed for a long second. When she opened them again, she smiled.

"This isn't just your show. It's his, too."

When Dad was finally led over to our table, Mom pushed a chair into his groping hands. He landed heavily in his seat, exhaustion and pain slumping his shoulders. The ever-present beer sat clutched in his right hand, foaming from his stumble across the deck.

"So how's the blind cheerleader?" I asked, smiling.

"Oh, great," he slurred, swinging his head toward nothing in particular. "You had some good runs today, bud."

"How did you keep track?"

Dad leaned back in his chair and laced his fingers together behind his head.

"Oh, ya know, people would tell me what you were doing and where you were on the hill, so for most of the race I'd just listen and imagine what was going on. I've seen you ski so much that it was pretty easy. And then at the last minute, they'd tell me when you were almost finished, and I'd pull my hat and glasses up, and then my eye patch. It hurt like hell, but I could still kinda make you out during the last few turns."

He split a clumsy grin and swigged his beer in the sun. We sat there a while, surrounded by ski buddies and family, until the dropping temperature and alpenglow told us it was time to leave and ready ourselves for the next day.

WOUNDED VIGILANTE

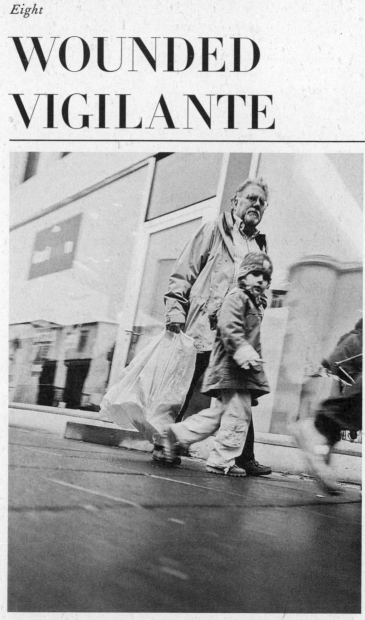

Reykjavik, Iceland

The early summer sun warmed my face as I rocked gently back and forth on top of a slow-rolling flatbed trailer. In the bright light, it was easier to keep my eyes closed. I tried to shut out the din of the crowd and focus instead on the glow of the sun illuminating my eyelids. This was my moment of pride, and I wanted to enjoy it. I was surrounded by friends who needed me in that time, that place, and it felt good to be part of a group, to be part of a *team*.

Even as I took in a big lungful of air, it was hard to keep a smile from my lips. When I opened my eyes, I was staring up into clear blue sky, unmarred except for the stream of blood shooting almost thirty feet into the air. As I rolled my head to the side, I could see the crowd of faces that lined the main street of Helena staring back at me.

I tried to scream, but my voice faltered. I'd been crying out since eleven that morning, and after an hour of near-constant bellowing, my vocal cords were ragged. All I could do was watch as we rolled through the main street of the city, passing hundreds of families and children, all cackling with glee as tiny droplets of gore rained down on them.

Watching the outfit of each laughing spectator turn into a mess of bloody polka dots was surreal. I turned my head away

from the scene to see how my leg was doing. The answer was "not good." I'd been shot twice, the second arrow having been buried in my right thigh. The blood pumping out of the wound was dark, and I studied the liquid as it flowed onto the operating table.

My seventeen-year-old classmate pulled out the handsaw from under the table. "It's in the bone!" Jeff screamed above the roar of the truck that was pulling us through town.

"I know! Just get it off already!" I yelled.

"Okay, we're gonna do it!" Jeff called back, as another buddy positioned the saw just above the wound and began running it back and forth, cutting through my jeans and deeply into the limb beneath. I pounded on the table and the blood spurted even higher, glistening as it rose toward the bright summer sky.

I was lying on a makeshift operating table that had been created out of a plank of plywood, balanced between two empty oil drums. To make the table appear more convincing, Jeff had placed a white sheet over the structure before he and a couple of friends had put me on it. The white sheet was now totally saturated with the red liquid that had been flowing since the annual Helena Vigilante Parade began.

The Vigilante Parade is an event that has overtaken downtown Helena each May since 1925. Originally created by Albert Robert, a former principal of Helena High School, the parade was meant to redirect "junior/senior class aggressions" into something more productive than pulling pranks on younger classmates.

So (and I have no idea how he came up with this solution) Mr. Robert decided that each year there would be a parade that

would run the length of Helena's historical downtown district. Every float in the parade was to be created by the junior and senior high school students and was supposed to relate (no matter how flimsily) to Montana's history.

If you've ever tuned in to see the Thanksgiving or St. Patrick's Day parade held annually in New York, then I'm sure you've seen all of the grandeur and hoopla that hundreds of skilled workers and months of preparation can produce. Take those same workers, get them drunk one morning, and tell them they had to produce a completed float by lunchtime. Then, take whatever drunken disaster they birthed and sprinkle some teenagers dressed in vintage clothes on top of the float. These kids can dress as cowboys, prostitutes, firefighters—anything—as long as they play their historic role with total conviction. Finally, multiply the whole scene by 174, and you come close to what the Vigilante Parade is like.

The utter insanity of the parade was a fact known, if not enjoyed, by almost everyone. School officials tried their best to keep the event as safe as possible, but still, nearly every rule for the parade had evolved as a result of a previous disaster. These rules included no mud fights, no discharging of weapons, no drinking, and no fires—or hot tubs—on the floats. Those are the sorts of rules broken more often by riots than city-sanctioned events. No wonder so many people attended every year.

Jeff and I had come up with the idea for our float almost a month before the parade, though it should be noted that our discussion was limited to how awesome it would be to chop off a fake leg of mine for a school project. Everything else—from the cowboy costumes to the fake surgeon's room—was just window dressing. All we really cared about was that our concept be as

dramatic and gory as possible. I had an almost morbid sense of pride about my role in the group. I had stopped to consider the morality of exploiting my lack of legs for the sake of a parade float, but not for long. I was much more focused on the fact that I was a valuable part of a group. That didn't happen all that often.

For the most part, I'd had a fantastic time in high school. Classes were fairly easy, and I breezed through each year with honor roll grades and minimal effort. By and large, I had great teachers who not only sparked my academic interests but were also tolerant of all the classes I missed due to ski racing.

The problem wasn't that I lacked friends at school. On the contrary, I had a pretty active social life that kept me away from home, even when I wasn't out skiing. I could, if I wanted, almost always find a group of people to be around.

The problem was that I never felt as if I *contributed* to a group. I wasn't on a soccer team and I didn't play basketball. In gym class, I usually lifted weights while the rest of my class ran laps or played field sports. And on the weekends (as well as during nearly a month of scattered absences due to races or training), when most of my nonathletic buddies were hanging out with each other, I was two hours east of Helena, skiing with the Dirtbags. So while I had people to hang out with, I never felt as if I was all that necessary to anyone. All of the work my parents and I had made toward my independence had left me feeling disconnected—surrounded by people, sure, but not truly part of anything.

And that's what I wanted, to be a necessary cog in a team: to have in-jokes and shared experiences that went beyond sharing a class, or having lunch with someone in the halls. However

morbid, I was proud now of coming up with the idea of having my leg chopped off. I reveled in the chance to really be a needed part of the group.

While there were five people on the team, Jeff, David, and I quickly became the key players. Jeff was to come up with the trailer and supplies to build the float. David was supposed to be the brains behind our float and was in charge of helping to construct the legs, as well as develop a system to keep blood continually flowing throughout the parade. My job was to writhe and scream as the other two sawed off my leg with a couple of dull bone saws.

The morning before Vigilante Day, we gathered at Jeff's house and set to work making the fake legs. Using some bolts, rope, and wood scraps, we were able to cobble together something that looked like my lower half. It was funny watching high school kids create what doctors and prosthetic manufacturers had spent years working on. While I wouldn't be able to walk with these new legs, they were already providing far more amusement than the old ones that I had given up.

Next came the arrow placement. We knew that the arrowhead had to sink deep, and after slamming it into the legs by hand, we realized that it wouldn't stick into the wooden limbs strongly enough to last through the whole parade. So, after some deliberation and rummaging around in Jeff's garage for a bow, we decided we'd shoot the legs for real. After a couple of missed shots, Jeff managed to sink an arrow just above the kneecap, and we set about hauling the now-wounded legs back to the trailer.

We weren't out to make a float that just showed an amputation, but one that had all the carnage of a B horror movie. And we didn't want the blood to just leak out, but to jet into the air

like a fireworks show from hell. This was David's domain, and by midday he'd managed to rig up a compressor that was capable of firing streams of liquid almost thirty feet high. The first successful test of his homemade contraption yielded cheers and hoots from the other guys on the team, but David was quick to rein us in.

"Yeah, it shoots high, but that means we're going to run out of blood real fast."

"How much do you think we'll need?" I asked.

David stood there, looking down into the ten-gallon bucket where his invention lay, and chewed his lower lip in thought.

"Well, I can stay underneath the operating table and monitor the blood flow, but even then we'll probably need twenty gallons."

We all nodded sagely.

"Better make it thirty," Jeff said. "We can just use these ten-gallon buckets and stack them under the operating table."

David and I had volunteered earlier that morning to create the blood mixture, so we loaded up into his old white pickup as the rest of the boys headed inside for lunch. We were cruising the aisles of Walmart twenty minutes later, trying to figure out what could create thirty gallons of dark red liquid for cheap.

"Would paint work?" I asked, looking at a wall of cans and wondering if there were any colors, somewhere between the Sierra Whites and Oxford Browns, that would suit our needs.

David brought me back to earth. "Nah, it'll clog the compressor. We need something more watery than that."

In one of the back aisles was a shelf devoted to concentrated dyes, and we stared at the lineup of bottles, their prices posted underneath on bright orange tags.

"We'll need some blue and red to make it look dark," David

said as I riffled through some of the small dye canisters, "but these are all so expensive."

"How about this?" I asked, tossing a large bottle at him.

David scanned the back label of the bottle. He frowned. "It says that it's permanent. And industrial strength."

I looked over at the orange price tag. "It says it's $3.50."

There was a moment of silence as we both considered the possible consequences of using dye that was going to rain down on dozens of parade goers, ruining their clothes.

Finally, David shrugged and grabbed two more bottles off the shelf.

"We're on a budget."

On the ride home, we tried to justify the purchase.

"Maybe if it's diluted, it won't stain that bad."

"Yeah, I'm sure it will wash out."

After arriving back at Jeff's house, we popped the cap off the first bottle and immediately realized how much we'd been lying to ourselves. The stuff smelled like battery acid and looked almost black. It was definitely going to stain.

In front of us stood three ten-gallon buckets. The first two had already been filled with water, and a garden hose was draped over the third. We gathered around as David did the honors of pouring out the first bottle of dye. When it hit the water, the black liquid almost immediately bloomed outward, turning red in the process. David threw in a quick dash of blue dye, and repeated the mixture for each bucket. By the time he was done, we had blood. It didn't look *exactly* like the real stuff, but it was pretty close. Besides, sawing off a leg while I screamed in mock agony would probably sell the scene more than the tint of the stuff coming out of me.

The next morning, we all wore ill-fitting ranch shirts from the Salvation Army as we piled onto the float. We started down the road, and every time I pounded on the table, David activated the compressor. The dark liquid shot up through a pair of plastic tubes that ran through the surgeon's table and into my fake legs, and poked out just above the arrow lodged in my thigh. The average human body contains about one and a half gallons of blood; during the course of the parade, we pumped twenty-eight.

By the time our float had reached the end of the parade route, the dye had soaked itself into our skin and clothes. Every inch of our body had been stained red, and as we walked through the crowd in order to catch some of the last floats, we couldn't help but smile, our white teeth standing out from our otherwise blood-soaked wardrobe. Some people were amused; others were not.

"I think we're getting the evil eye," Jeff said as we walked past two old men, sitting in lawn chairs by the side of the street. I turned and looked to see them scowling at us. They both had a few light spatters of red on their chests. The fatter of the two shook his head as we passed, his leathery jowls creasing over the collar of his shirt.

I smiled. "Good, huh?" I asked, trying to lighten the mood.

"It was offensive," he replied as he shifted his weight in the plastic chair.

My ears warmed with embarrassment. They weren't the only ones who were offended, either. While some people seemed to smile and get the joke, there were just as many who frowned at us. I kept joking with the other guys, but it seemed more forced than earlier. I'd been so focused on trying to make my buddies laugh, that I forgot that other people might not see the humor

in what we'd created. I tried to shrug it off, but the disapproval nagged at me. I stuck around for twenty minutes after that, congratulating the other guys on the team, before making the long slog back to my car.

By the time I made it home, the dye had dried into my skin. My fingernails were the worst, as the tint had stained my cuticles almost purple. I got a quick glimpse of myself in the rearview mirror and chuckled at the stained mess that I'd become. My face had changed over the past couple of years; I'd lost weight due to my increasingly demanding skiing schedule, and I had thinned out as a result. I'd also entered the manly world of facial hair, and patches of stubble littered my jawline as I stared into the mirror.

Dad was in the driveway, changing the oil in Mom's car. He looked over at me as I dragged my pile of sopping clothes toward the door.

"You're an idiot," he laughed, shaking his head.

"You want a hug?" I asked, sauntering toward him.

"Get the hell away from me and go get in the shower," he yelled. "And *don't* track any of that stuff in on Mom's carpet or she'll have my ass *and* yours."

In the shower, I desperately scrubbed at my nails as red water trickled down the drain. I wondered about some of the looks and comments we'd received that afternoon. I was angry with myself for not being aware of the bigger picture. During the building of the float, I'd only paid attention to making my friends laugh, without thinking that at some point, the Helena public was going to witness whatever monstrosity we built. I packed the twinge of shame away and got out of the shower just as the water was beginning to go cold.

Now, as I look back on it, I still feel conflicted about what I did. I did have that moment of feeling like I belonged to a group, like I was not only a part of something, but also necessary in its creation and momentum. The week after the parade I kept joking around with the other guys in school, recalling some of the more epic squirts of blood or memorable reactions from the crowd. At the time, I refused to let someone else's sense of what was appropriate stop me from having a laugh at my own expense. I figured that if I had to deal with the crap that came along with being a legless dude, I was going to revel in the occasional fun parts as well.

But now I wonder about that sentiment. I wonder whether the price of fitting in was worth the cost of some of the offense we caused. More important, I wonder what it said about me at the time that the only moment of "feeling necessary" to a project was when I was made a spectacle of. Given the opportunity to go back and do things again, I don't know if I would have agreed to have my leg chopped off.

One thing I am certain of, however, is the need for a much-belated apology. To all those people watching the 2003 Vigilante Day Parade—I'm so sorry about the clothes.

SKATEBOARD

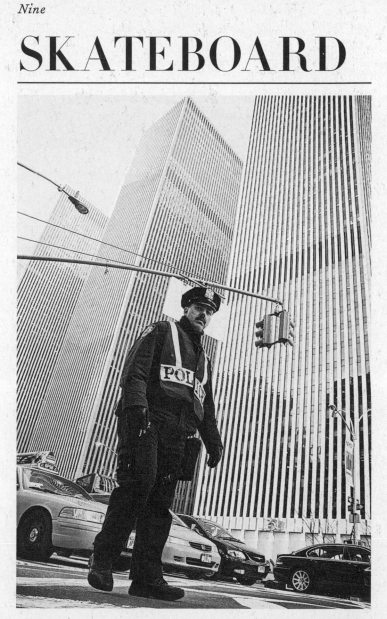

New York, United States

I was *7,683 miles* away from my home in Helena, yet as my train rolled across the South Island of New Zealand, I couldn't help but catalog the similarities. The mountains were straw-colored behemoths that still held snow on their tallest peaks. Their size was magnified to even greater proportions by the flat plains from which they erupted. I stared out the window, marveling at a horizon I felt I had *almost* seen before. It looked like a condensed version of Montana, squishing thousands of acres and landscapes into one small, jagged horizon line.

I was traveling on the TranzAlpine Express, which bisected the South Island, and was bound for the west coast town of Greymouth. The train rolled into a dark tunnel that passed underneath one of the massive mountains comprising the Southern Alps; when it emerged on the other side, the world had gone from dry tussock and plains to a green, cascading mess of mud and ferns that lined the slopes on either side of us.

Definitely in a different country now, I thought as I shuffled closer to my lumpy backpack.

My bag had been hastily packed only hours before in Christchurch. I had bought my ticket to travel across the country on the urge to see more of New Zealand and to get away from the unadventurous lifestyle of my cramped dorm room.

The ultimate goal of this excursion was to make it to Stewart Island, off the southernmost coast. On the map, it looked as far south as one could go, barring Antarctica. Delusions of adventure clouding my brain, I had been trying to plot how I would get to the island; but since I was going to hitchhike almost everywhere, it was tough to pin down a solid itinerary. I decided to take a train to the west coast and make up my route southward from there.

I was twenty, and after my first year studying at Montana State University in Bozeman, I had transferred to the University of Canterbury as part of a study abroad program. I had four weeks off from school as part of a term break, and I wanted to make the most of it. But with no car, no money, and no real friends yet, I decided to head out alone. A school-sponsored trip would have provided four weeks of activity, but I didn't want to hold anyone else up.

Earlier in the year, I had tried to keep up with a group of hikers on a five-mile walk, and I'd arrived four hours later than everyone else. Tired and utterly alone on the trail, I was fuming at myself for being dead last in a pack of forty. I had started before everyone else but was passed one at a time by every hiker in the group. Their occasional encouragement stung more than silence and only served to remind me that no matter how much pride or determination I had, it wasn't going to compensate for short strides and hands for feet. So with that frustration still percolating in my head, I gave up on the idea of having a travel buddy. Instead, I just accepted that I would be alone. It was easier not having to deal with my hurt pride or the expectations of others.

As the four-hour train ride passed, I squinted down at my belongings rattling around on the train floor. The first item was a

longboard, a flexible, longer version of a skateboard; once new, it was now beaten to shades of dull black and brown.

I had found that the longboard was a much more practical tool than a wheelchair for getting around in another country. It was fairly cheap, as my full setup cost $150. Another crucial element was that it was replaceable. Unlike a wheelchair or set of legs, I could buy a longboard off the shelf of a local skate shop— a hugely comforting convenience. Most important, though, was its speed. On flat land, I could nearly keep up with a bicycle, and on it I was able to get almost anywhere in Christchurch.

The next item lying near my board was an intensely smelly pair of gloves wrapped in nearly two inches of duct tape. Once I began using the longboard regularly, normal off-the-shelf gloves could no longer survive more than a day's worth of riding. Within twenty minutes, my fingers poked through the burned-out tips. To compensate, I wrapped thin strips of duct tape around the fingers until they expanded by nearly an inch. By the time I was finished, they looked like no other glove I'd ever seen—somewhere between an armored medieval gauntlet and the inflated phalanges of a lizard.

The only other crucial item was an evolved version of the leather butt-moccasin that my grandpa had dreamed up years ago. With the help of a friend who had worked on my prosthetic legs, we began making improvements to the once-formless piece of leather. First, we added a thick sole that left circular Birkenstock imprints on the ground. Next, we added plastic and metal inserts to give the shoe shape and strength. Finally, there was a custom butt-bed for ultimate comfort. By the time it had reached its pinnacle of design, my shoe looked more like a leather flowerpot than it did a crude, formless purse.

These were my new forms of getting around, adaptations that I'd made during my first few months in Christchurch. Ultimately, these little inventions were the most important things that I'd brought on the trip. Unlike any of the MacGyvers of the past, these had been generated solely from my own ingenuity, and I felt proud knowing that I could solve the problems that my doctors and parents once tried to shoulder.

As the train rumbled toward my destination, I nervously ran through the list of things that I'd hastily stuffed into my backpack that morning. I'd made a last-minute visit to the grocery store before I left, trying to buy food that was cheap and easy to eat on the road. I had been in the checkout line, wheeling around on my skateboard and trying to brush off some of the dust that clung to my hands from the store floor, when I heard a little kid shouting.

"Mom! Look at that guy! What's wrong with him?" he asked, poking his mother in the thigh as she distractedly rang up items from her basket. "He might have been bitten by a shark!" the boy added, his imagination answering his own question before his mother could.

I was the next person in line, so when he craned his head toward me, we locked eyes. The number of times kids are actually able to stand face-to-face with an adult is pretty rare, and his eyebrows shot up in shock. Trying to add a bit of levity to the situation, I crossed my eyes at him.

If I'd been his age and seen a legless guy on a skateboard, my reaction would have been identical. I'd felt that same curiosity when I was kid; I remembered blurting out similar questions about a blind man in a checkout line when I was little. So while I certainly understood his curiosity, I figured I could at least have

some fun with this little guy. I crossed my eyes at him again, making him squeal.

"Moooooooooom!" He turned back and wrapped his arms around his mother's leg. Finally, he got her attention, and before he could eke out anything else, she'd cupped a hand over his mouth and pushed him in front of her. She quickly looked down at me and let out an embarrassed "sorry." The mom kept the boy corralled ahead of her while I idly eyed my groceries, waiting for my turn to check out. Once she'd snapped her receipt from the checker's hands, she hastily walked out, pushing the kid ahead of her as he tried to steal one last glance at me.

As I checked out, I kept thinking of the commando-like efficiency with which the mother had handled her son. I felt bad for the kid but realized that I'd seen that exchange play out many, many times over the years. Kids had pointed and yelled and gasped at me for as long as I could remember. Some remained well behaved, only peeking at me from behind a parent's leg, while some went into hysterics. I'd grown fairly used to children's reactions; at least they were honest. It was the adults' lack of common courtesy that bothered me.

The train finally lurched to a stop, and I took a deep breath, saddling my backpack. When I hopped off the platform, I was greeted with my first Kiwi town outside of what had become a familiar Christchurch. Aptly named on two counts, Greymouth was situated at the mouth of the Grey River and was blanketed by gray skies or rain nearly every day. It wasn't the most welcoming city, and the guidebooks spent more pages on how to get *out* of Greymouth than on what there was to do in the town itself. But it was en route to Stewart Island and the obvious place to stop.

Here, a rainstorm seemed less an event than simply a state of existence. The locals could be spotted miles away. Heads bowed, they walked slowly along the street, not bothering to huddle under the archways of the various shops like the half dozen tourists scattered around the city. The biggest telltale sign of the denizens was the fact that not one of them wore rain gear. In a town with that much water, a certain amount of "moisture fatalism" had arisen; with the mind-set that everything would become wet regardless, they didn't bother with vain attempts to stay dry.

The buildings helped to reinforce the gray motif of the town, making me wonder if it was a style mandated by the mayor. I wandered around for a time, trying to find some cheap entertainment, and eventually asked an unparkaed local if there was a bookstore nearby.

He stared down at me, in shock that I actually had spoken to him. After a moment, he sputtered out, "Where are you from?"

"USA. I haven't been here long."

"Greymouth isn't much of a reading town. What happened to your legs, mate?" he fired back.

"I was born like this. Nothing special."

"Oh. Sorry," he muttered. He shrugged his shoulders and shuffled off into the downpour.

With this encounter, my self-confidence slipped a bit more. While the interaction was pretty insignificant, it was the look— the shocked expression on the man's face—that made me retreat inward.

I kept to the back streets the rest of that afternoon, choosing to navigate the fractured asphalt alleys rather than the wider— and more populated—main streets. I wanted to get a feel for the town but wasn't in the mood to interact with anyone else. As

I neared the north side, the buildings turned to dockyards and eventually dwindled to nothing but a road stretching out toward the Tasman Sea.

Wanting to get a photograph of the river joining with the Tasman, I hopped off my longboard and stashed it in the ditch. Written on the bottom of the deck was my name and address, as well as the words

"THIS IS A LEGLESS GUY'S SKATEBOARD. PLEASE, PLEASE, DON'T STEAL."

It was the most effective warning that I could muster, considering how important the board was to me. I just hoped that whoever saw it would read my notice before getting any ideas.

When I looked behind me, I saw a massive river recently gorged on the torrential rains that had been steadily falling. I took a snapshot of the scene and sat on the beach for an hour watching the clouds mix with the waves, which were breaking far out. Coming from landlocked Montana, the concept of a horizon only limited by the curvature of the earth still inspired amazement. The view emphasized just how far away from home I was.

Thankfully, my longboard was still in place when I returned, and on my way back to town, I began to regain some confidence about this whole undertaking. I focused on the flex of the board as my pushing gained a cadence and bounce that simulated the pace of a jogger. I resolved to quit my self-pity and just deal with whatever situations were going to present themselves in the coming weeks. Besides, moaning and gazing out at lonely vistas won't get you a hostel room or any food in your stomach.

Standing out from the general aesthetic of the town was a Crayola-colored building named The Duke. It was a hostel advertising a room for $20 a night, including a free beer for every evening of stay. Realizing that I hadn't packed any bread in my bag, I figured that a liquid loaf would be a decent substitute.

After checking in, I wandered into the main room and saw two guys about my age checking their e-mail on a couple of computers pressed against the far wall. I swung up on a chair next to them and gave a quick "hello" as I logged in to my e-mail. The guy on the far end, dressed conservatively, with a week's stubble on his face, gave me a quick nod and went back to his screen. The fellow next to me took a bit longer as his eyes widened beneath the unbent bill of his Penn State football cap. He stuck out his hand.

"Hey, what's up? I'm JC."

His buddy looked up again and responded briskly.

"I'm Dan; how's it going."

I gave the solemn dude a nod. "Hey, I'm Kevin," I said, and went back to my computer screen.

I could hear the "bwing bwing" of an instant messaging service as JC's fingers banged a bit enthusiastically on the keyboard. I peeked over to see what the fuss was about.

JC _ 3033: *holy shit some dude just walked in without legs*.

HIS _ FRIEND _ 989: *then he definitely didn't just "walk in"*

JC let out a snort of stifled laughter and closed the conversation. I hadn't received any mail aside from a worried mother back home, so I told Mom that I'd arrived safely, killed the window, and turned to JC.

"So, have you guys been here long?"

"Nah, dude, we just got in yesterday. Drove down here from Wellington a couple of days ago."

I perked up a little bit. They had a car? I began planning how I could convince them that they needed a travel buddy in their backseat.

"Yeah, man, we went on a brewery tour today and got a bunch of free booze! I'm pretty drunk now . . . when'd you get here?"

"Came in this morning from Christchurch on the train. So where are you guys headed after this?"

JC looked over at Dan. "I think it's called Franz Josef?"

Dan piped up: "Yeah, we're headed south to Franz Josef after a white-water excursion tomorrow."

"You guys don't by any chance have some extra room in your car?" I asked. "I don't take up much space, and I need a ride in that direction."

"Yeah, man!" JC blurted before Dan had a chance to open his mouth.

Success! I hadn't planned on my first hitch being so easy and had instead envisioned long, dark nights with my thumb out by the roadside. It was a romantic idea, but not a comfortable one, and I smiled at the knowledge that I had a ride secured for at least one day.

But something was clearly percolating in JC's head, and as we left the computer room to head upstairs to the hostel beds, he nervously whispered, "Sooooo, what happened, bro?"

"Oh, I was born without 'em."

The data clicked in, eroding all of the other tragic possibilities of how I came to be.

"Oh, cool man. No worries."

It was a short interaction, one that I'd become so used to over the years that I responded almost without thinking. I'd seen the question bubbling up in people before. It's the combination of genuine curiosity and memories of getting whacked by your mom for asking an embarrassing question too loudly.

Most of us are taught early on that open curiosity can be offensive and upsetting if it's directed at someone, so "the question" was always asked in a heavy, serious tone. To diffuse the situation, I'd learned years ago to counter with something that sounded pretty nonchalant. Yep. No legs. Born without 'em. No big deal. Let's move on.

And so we moved on. After unpacking our bags in a shared room, we went down to the attached pub to make good on the hostel's promise of a free beer. The inside of the bar was painted bright purple, and in back was a group of fishermen who walked the thin line between deep-sea angler and pirate.

Perched on the wobbly stool of the bar, I tried to get a better sense of the guys with whom I was sharing both a drink and a ride. Dan and JC were from Philly, yet they had never met each other until arriving in New Zealand on the same study abroad program. But it was difficult to get too far into a conversation, as we had to yell above the jokes and curses coming from the men at the other end of the bar.

As our conversation began to wind down into the bottoms of our glasses, a gaggle of fishermen came in from the rain. This new group entered with a bit more swagger and a look that put them somewhere between auto mechanic and seafarer: tattoos to the wrist, body odor, and awkward facial hairstyles.

In the caboose of this troop of men was a dwarf. Wearing a large

white hooded sweatshirt and walking with a drunken swagger, he stuck out almost more than I did. I stared openly as he crossed the sticky bar floor and hopped onto the neighboring stool.

"Hi, Kevin Connolly, how's it going?" he said. "You're from Montana in the U.S., right? What do you think of Greymouth?" he asked quickly, with a leer.

More than a little shocked, I choked on my last mouthful of beer and sputtered a confused "What?"

"Yeah, you're Kevin Connolly, right? How do you think I knew that?"

"Umm, no idea."

"Skateboard. I was gonna steal it for a ride before I saw your info on the bottom of the board."

"I'm glad you didn't."

He stuck out his hand. "I'm Mark."

Still a little pissed, I frowned and threw my hand out. "Hey I'm Ke—"

"Yeah, I got it."

The typical "where you from/similarities between the countries" conversation started as Mark wobbled precariously on his bar stool. He'd been drinking before coming to The Duke and hastened to tell me that he was expecting a big night. Not knowing what to say, I chuckled into my pint glass and let the conversation lull. It took only a few seconds before he blurted out what had really been on his mind all along.

"Do you wanna fight?" he asked.

"What?"

"It would be great. I've never wrestled anyone like you, and we're the same size."

Trying to get out of it, I fumbled for an excuse. "But you're taller than me."

"Only by a bit. It's close enough."

To be honest, he did have a point. It's not as if his extra four centimeters in stature would guarantee him a win. Still, I wasn't keen on the idea of brawling on my first night. Memories flashed back to my days of wrestling in the second-level "midget" category, and all of the matches I had lost over the season. Suddenly, Mark became the physical manifestation of all the beatings I'd taken ten years prior, and I began to stutter out a refusal.

But my two compatriots were having none of my reluctance.

"Bro, that's awesome!" yelled JC as he shook both of his fists above the bar. "You gotta do it, man," he belched, tripping over his words.

"Yeah, you really, really should," Dan echoed.

I felt trapped. Either I was going to fight this Mark guy, and potentially make a fool out of myself, or lose my masculinity (and maybe my ride) if I didn't start slinging fists. Reluctantly, I began to discuss strategy.

"How would we do it?"

"I'll probably throw something at you and then just run and punch until you're down." Mark seemed confident, and I got the feeling that this strategy had worked before on bigger folks than me.

I knew he would have me in terms of speed. By the way he'd walked in, I guessed that those little legs could carry him pretty fast across our makeshift arena. I also surmised that his four limbs might be able to overwhelm my two, simply by virtue of quantity. But I knew that I had the reach on him, and I began to

concoct a strategy in which I could hold him at a distance with my hand.

I took a deep breath for the second time that day. "All right. But I gotta get my camera. My friends won't believe it otherwise."

Mark nodded. "I'll be here."

During this, the three other fishermen who had paraded in with Mark began noting our conversation with quite a bit of disdain.

"Hey! I don't think this is right, Mark."

Apparently laughing at racial slurs was okay, but the idea of two vertically challenged combatants testing their physical prowess was too much for these guys to handle.

I hustled out the door and up to my room, wanting to get this over with as soon as possible. But when I returned only a few minutes later, Mark was nowhere to be seen. Dan and JC looked confused, the men in the back of the bar had grown silent, and Mark's friends had all disappeared save for one, standing with his foot halfway out the door.

"Mark went to smoke. He won't be back."

I turned to Dan and JC, who offered blank looks and shrugs as they finished their beers. It was clear that the atmosphere of the place had changed entirely within the hundred seconds I'd been gone.

Later that night, as I sank my buzzed body onto the thin mattress, I looked through the photographs in my camera. In the span of one day, I'd witnessed some of the most polarizing reactions from people with regard to me, to Mark, and to the differences that make us curious about and reviled to one another. I

wasn't sure what the remainder of the trip would be like, but I thought that if I were able to make it through this one night, I could probably get through the rest.

I thought about my parents back home, sitting up in Montana watching the snow thaw in the neighboring Elkhorn Mountains. I had spoken with them regularly since landing in New Zealand, but for all their verbal support, neither of them had ever left the United States, and neither had experienced my physical situation. On my skateboard and halfway across the world, I felt as if I had come to a place where they couldn't advise me. I'd have to make it up as I went. And for the first time, that actually felt pretty good.

FORCED
BLESSINGS

Split, Croatia

As my plane touched down in Kiev, I nervously thumbed the empty square on my passport where a temporary visa would have been placed. Due to recent political hiccups, the visa requirements seemed to change on an almost daily basis. One day, a visa was mandatory; the next, you could enter without one. I wasn't sure if I'd even be allowed in the country, and if not, the rest of my travel plans would collapse, as well.

Since this trip would be my last international "hoorah" before buckling down to my academic workload back in Bozeman, I had gone online and bought the cheapest tickets I could find to some of the places I'd always wanted to visit: Vienna, Austria; Dublin, Ireland; and New York City. The stop in Kiev was to reunite with my friend Serge, whom I'd met in high school when we were both on a three-week, school-sponsored exchange program.

After the other passengers had cleared off the plane, I quickly skated down the narrow aisle toward the somewhat shocked attendants waving goodbye. I skipped baggage claim, as I had again brought only a single backpack. As I stood in line at passport control, I tried to think inconspicuous thoughts, hoping that I'd be able to slide through without a hassle.

Then someone tapped me on the shoulder. I turned around and looked up into the face of a security official. He appeared younger than me by a few years, but that did little to alleviate the knot in my stomach.

He spoke some Ukrainian, and then, after a moment, gestured.

I hesitated, not sure what he wanted.

"Yes, yes," he muttered, his waving becoming more urgent, indicating that I was to come with him.

I mentally cursed as we twisted through the labyrinthine halls of the airport's security offices. Finally I was deposited in a white room with only a couple of chairs and left to wait. After five minutes, the young official escorted two paunchy senior officers through the door. They stood for a moment, evaluating my appearance. I couldn't argue that I was the pinnacle of respectability, with my two days of stubble and a sweat-stained T-shirt, but still I straightened up and tried to conjure the most honest face I could.

"Passport," said one of the new officers, gesturing impatiently. As I handed it to him, he asked before opening the document, "Where you stay?"

The question gave me pause. My plan had been to meet up with my friend Serge. We had been exchanging e-mails over the previous weeks, but his computer access was limited, and despite some increasingly frantic questions on my end, I hadn't received his address or how I would contact him in Kiev. Not the best of situations.

"Uhhh . . . hotel. Kreschatik."

The answer seemed to suit, so he moved on.

"And who take care of you?"

I looked at him, confused.

"Who take care of you?"

"Nobody takes care of me."

Now it was his turn to look confused.

"Uhh, me." I tapped my chest.

The portly guy looked over at his two colleagues and shrugged his shoulders. They disappeared with my passport, and after I sweated it out for a few minutes, they returned. I opened my passport to see a reassuring tourist visa stamped into the book.

The young officer had brought back a wheelchair. He gestured into the seat of the thirty-year-old contraption that had barely fit through the door.

I shook my head. "Niet."

"Da, da." He gestured again.

"Niet."

"Da! D——" insisted the young man, before being cut off by the wave of his superior's hand. His shoulders slumped, and he began the difficult process of folding up the old, mechanical mess of a chair. I gave a happy nod to the older official as he ushered me out of the office.

As I entered the welcome area, my eyes began to frantically scan the expectant faces of the crowd, looking for Serge. I hoped I wouldn't have to make my way into town, knowing only a few words of Russian.

Relief flooded me as I spotted him: a lean, eighteen-year-old kid with sandy blond hair, struggling to throw his arms wide in the crushing crowd.

"HEEEY, DUUUUUDE!" Serge yelled, putting on his best American accent. We gave each other a big hug, then began

navigating through the throng of people. Finally making it to the exit, Serge hustled me outside and across the parking lot to an awaiting black sedan. I was stunned at the nice ride he had procured.

"Rolling in money now, huh?"

"No, no. This is my friend's," Serge replied, gesturing at the stern young driver who nodded at me. We piled into the back of the vehicle and before long were cruising toward his apartment on the outskirts of the city of Kiev.

"What do you want to do, man?"

"Probably just sleep," I yawned, feeling my eyes grow heavy as the setting winter sun burned red in the smog.

"Yes, I got your e-mail. Thirty-six hours is long. We will get food and then sleep."

As the driver turned off the main street, we entered a forest of towering apartment complexes. Each old, concrete monolith sported the spartan aesthetic of a structure built under Soviet rule, and as I stared up at the dreary, faceless walls, I wondered which one was Serge's.

These stark buildings comprised much of the outskirts of Kiev, and while I could see the beautiful churches and skyscrapers that sat across the Dnieper River, I knew that they hardly represented the world that Serge inhabited.

Serge turned to me as the driver navigated down the narrow alleys between the buildings.

"How is your family, dude?"

"Ah, they're good. Last I spoke with them, they said Montana was just starting to get cold. How about you?"

"Sadly, mother had a heart attack two months ago. She is okay, but it was scary."

I turned, my voice raising. "Why didn't you tell me?"

"These things happen here. You become used to it. I have heart murmurs and high blood pressure and may get an attack someday as well. Some people deny it, but I think these health problems may be from Chernobyl."

"Really?"

"Yes. Many health problems still happen. Kids are still born with defects sometimes. Like no legs or no arms or other things."

I recalled some of the pictures I had seen about the Chernobyl nuclear power plant disaster in 1986: infants lying on white hospital sheets, sporting any number of different maladies or deformations. Some had swollen heads or torsos, while others were missing fingers, or hands, or even legs.

It hurt to think of so much tragedy caused by a singular event, and I realized that despite the difficulties I'd had in my short life, things could've been much, much worse. Of all the ways one could lose their legs, mine had probably been the easiest on family and friends. Serge must have had dark thoughts of his own, and we remained silent until the car stopped outside one of the sturdy, concrete towers.

As Serge and I got out of the car, his tone turned stoic. "Such is life. We don't talk about it as much because there is so little we can do. The most we can do is joke about it. Sometimes it makes things not so bad."

The car roared off as we turned and walked into the darkened entrance of the building. I could hardly see anything when we entered, and it took my eyes a moment to adjust before I could make out the dim outline of a staircase spiraling upward through the gut of the building. Serge turned to me, whispering.

"I am on the sixth floor. Sorry, dude, but you must walk."

"That's all right. Do you mind carrying my skateboard?"

"No, hand it here," he said. The second it hit his hands, he turned and began to climb.

As I tailed behind, he called back over his shoulder, "Kevin, do you want to hear a joke? It is about what we talked about earlier."

"Yeah, sure," I said as I tried in vain to keep up.

"So a man goes on vacation to Chernobyl, and he decides to get a whore."

"Okay . . . " I said, already preparing myself for the worst.

"And when he takes her back to his hotel, she takes off her top, and he sees that she has three breasts! Well, then the man gets angry and he says, 'Three breasts! I'm not going to pay for that!' "

He had quickened his pace and was almost a flight ahead of me when he shouted the punch line.

"And so she says, 'You don't like my titties! Well, then, suck my dick!"

I could hear him cackling above me in the blackness. It sounded fake—that laugh—like he was trying to pull a veil over something too big and ugly to ever be fully obscured. Still, I chuckled loudly enough for him to hear.

My parents (especially Dad) had reveled in humor as dark and morbid as Serge's, and for a similar purpose. I could recite most of the jokes that he'd bellowed out over the years.

What do you call a guy with no legs in a hole? Phil.
What do you call a guy without legs trying to water-ski? Skip.
Trying to swim? Bob.

In front of a door? Matt.
What about in a pile of leaves? Russel.

I'd laughed at those jokes as well. Not because they were par-
ticularly funny or original, but because I *had to*. Jokes like these
pushed the weight of reality aside for a moment and trivialized
burdens that sometimes were too large to bear.

As I climbed the last flight of stairs to the landing of Serge's
apartment, I kept laughing.

"Good one," I said, my breath still coming out in foggy jets
from the exertion of the climb.

After navigating through the series of heavy locked doors
and into his flat, I dropped my pack on the floor of Serge's tiny
living room. It was barely dusk, but I could feel exhaustion
washing over me. Within moments I passed out amid the mess
of my belongings.

I woke up the next morning on Serge's floor. After a night of
listening to the rumbling tank that was his snoring, I was ready
for some instant coffee and a day out of the apartment. I loaded
up my camera, and we hopped down to the street to begin the
long venture into the center of the city.

As we walked through the market a few blocks away, I was
hit by the sights and odors of the ramshackle huts that sold a diz-
zying mix of food, electronics, and clothes, all of it manhandled
or used. The smell of body odor, old clothes, and cooking meat
brought back the memories of my first visit to Ukraine.

Serge and I met in October 2004 on an exchange grant during
my senior year at Helena High. The program allowed eighteen
Ukrainian and American students to travel to each other's coun-

tries for three weeks, to chronicle the experiences of World War II veterans. First the Ukrainian kids came to America, then we followed with a visit to their native land. In each country, there were ten or so vets willing to tell their story to a bunch of high school kids who probably weren't as engaged as they should have been.

The purpose of our exchange was interesting, but it was inevitable that we wanted to entertain the new kids, as well. Our days were packed with veteran interviews and showing the Ukrainian students the sights and activities of Montana. While Serge was able to maintain his focus during the more official moments of his visit, his primary desires boiled down to two things: drinking Coca-Cola and trying to seduce (as best as a sixteen-year-old can) "Uhmerican gurrlz." This seduction entailed one of three things:

Wearing a sleeveless shirt to showcase his small, wiry muscles.

Wearing no shirt to showcase his small, wiry muscles.

And finally, in the event the girl had yet to notice him, Serge would lift his intended target off the ground, again to showcase his small, wiry muscles.

The third step was his surefire way to "get" a girl—probably resulting from his hearing American slang without quite learning its true meaning. It makes you rethink all of the heavy lifting that might accompany an invitation to "pick you up around eight."

His first night at our house, Serge managed to down six Cokes in about forty minutes. He then proceeded to burn off the calories by chasing my screaming sisters around the house. As the screaming continued, Serge managed to herd the girls into the basement until a voice boomed from the top of the stairs:

"Serge—c'mere a minute!"

Still firing on all eight corn syrup–fueled cylinders, Serge heel-spun away from Meagan and Shannon to bolt up the stairs. He made it about four bounding steps before my dad stopped him. Planting one hand on his chest, he pushed Serge until his back was pressed flat against the wall.

"Don't you try anything with my daughters while you're here, or you'll be dead."

I watched Serge from the bottom step as he let out something akin to the whine of a trapped animal. "Don't," my dad emphasized as he let Serge go.

And with the house rules set, Serge changed his act and began to get along well with the whole family. His energy levels didn't change, and he still consumed the same amount of soda as before, but he exercised a bit more caution with my Uhmerican sisters.

Of all the students, Serge was the most fluent in English and was often the most focused when it came to conducting the veteran interviews. Once that first night passed, we became good friends. He had a peculiar charm that derived from alternating between sexed-up feral animal and hyperintelligent international student. He could speak Ukrainian, Russian, and German fluently and could hold his own in French.

After Serge's departure, Mom went to develop the half-exposed roll of film on his borrowed camera to send it to him in Ukraine. Expecting tourist photos, she instead found a dozen images of various girls' posteriors from around the school and town. Shot on a zoom, the pictures had the grainy aesthetics of telephoto wildlife photography. Serge—the voyeur auteur.

At the time of my current visit, Serge was putting himself

through college since his parents couldn't afford to help him. He was always hustling small jobs around Kiev, one moment working as a Russian translator for a law firm, the next acting as a cell phone delivery man.

The pace of his various occupations reared its head once we hit the streets. The farther we distanced ourselves from his apartment, the faster he walked, until I was pushing my longboard full force just to keep up. His delivery job had put a bit of grace into the spastic body that I remembered from a few years earlier; as he casually pushed and shoved his way through the crowds, I was forced to navigate my board through the momentary wake that Serge had bashed out only moments before.

Kiev, it seemed, had little regard for crosswalks. As a result, almost every time that we had to cross a street (excluding a few frantic jaywalks), Serge and I dove underground. Three flights of dusty stone stairs dropped us into the darkness of a tunnel system that eventually connected to the other side of the street. Each set of tunnels had its own underground community, and as my eyes readjusted to the dim green fluorescent light, I caught sight of the beggars and buskers (there was a very fine line between the two) who populated the underground.

Then, as quickly as I got a sense of the tunnel, we would rush up another three flights and into the brisk open air. After my first painfully slow attempt trying to climb the stairs with one arm while holding my board with the other, I swallowed my pride and requested that Serge adopt one more occupation: skateboard Sherpa. Immediately, the stairs became less intimidating, as my arms were able to share the burden of each set of steps.

While the shops and underground tunnels were exciting, they were nothing in comparison to the subway system. Situated even

deeper underground than the crosswalks, the stations were so packed with people that it was impossible to skate.

Instead, Serge would carry the board as I breathlessly tried to keep up while dodging a dangerous Ukrainian fashion: stiletto heels. At every subway stop, you could hear hundreds of hard *"clacks!"* as heels drove down onto the flesh-colored tiles. The sound conjured images of typewriters, sewing machines, and puncture wounds.

Trying to hop onto my first subway car, my left arm strayed a bit and got stabbed by a heel that fit neatly between two tendons on the back of my hand. As the car lurched to a start, I looked down to see black beads ebbing up from the circular slice in my skin. It could have been much worse: the proper angle and force would have put the stiletto straight through my hand.

I watched the dark blood coagulate into sludge on the top of my hand, the riders' lower bodies creating a helmet for my head in the jam-packed subway. In a sense, the compression was comforting. Granted, the humid atmosphere down by the bikini zones of the subway goers was less than pleasant. But it was at least consoling that in the event of a derailment, I would have been pleasantly cushioned, maybe even saved.

"Gross," you say. And you might be right.

Asses, when constantly positioned in front of your face, fail to elicit the same sort of desire, lust, or disgust that they might ignite in most people. Instead, as the novelty dies, these body parts fall into the general category of my life on public transit. Butts are my wallpaper—albeit a bulbous, undulating brand that most people wouldn't dare tack to a wall—as well as my protection.

It is important to have a cushion when the bus or subway starts to jostle. Youthful, attractive types—gym-hardened men

and women—will only lead to bruises and boxer's ear. Instead, I look for the curves: people who have let up on their figure but, one desperately hopes, not their hygiene.

Actual girth is more of an asset on the street. When navigating a crowd at such a low level, it's imperative to find an unwitting point person who can break a trail while I reap the benefits of an empty wake. Of course, the larger the rear, the wider the wake. I've found that the extra space is well worth the sacrifice in speed that normally goes with following a particularly spacious person.

But it wasn't the Ukrainian buttocks that made the first day of travel different from those in New Zealand; it was the reactions people had to me. Unabashed looks of pity, concern, and fear openly contorted the features of so many people who passed by. While I had been stared at the last time I was here, the expressions on people's faces had been much less intense: maybe a passing glance, but never the sort of towering, emotive gazes I was getting as we navigated slowly toward Kreschatik Street, the epicenter of Kiev.

Maybe it was because on my last trip, I had used a wheelchair exclusively to get around. In a way, that wheelchair packaged me into something that was socially acceptable. I didn't have legs, but the wheelchair implied that I was being looked after or dealt with.

Being on a skateboard brought up too many questions. *Why is he riding that thing? Can't he afford a wheelchair? Is he homeless?* Suddenly, I wasn't packaged neatly into the socially acceptable script of being wheelchair-bound; I was more of a spectacle, a foreigner breaking the mold of how a disabled guy should act. And while the skateboard afforded me so much more freedom

than a wheelchair in terms of getting around, I began to consider what other people might glean from my mode of transport. It wasn't all good.

These thoughts were percolating in my head as we hiked the last flight of stairs into the pallid sun. Kreschatik Street was more a multiterraced boulevard than a road, and it was continually packed with vehicles and pedestrians at almost any hour. It was also one of the main thoroughfares that led to Independence Square, a massive plaza flanked on all sides by towering commercial buildings.

For the first time since my arrival, our pace slowed to a stroll, and we stopped for a moment to enjoy the enormity of the infrastructure before us. Busted-up taxis, black sedans, and coach buses spun in all directions, bringing people to the heart of the city.

It was here that you could get a visual of a country's identity in one fell swoop. Two JumboTrons hung from a couple of the larger buildings, advertising the newest musical act or Western film. A multitiered McDonald's occupied the busiest corner of the plaza, with a line extending out the building.

Yet, despite the Western touches, the influence of their former Eastern occupation was in evidence. The Soviet sickle and hammer could still be spotted on some stone awnings or at the front of an old gate. It was a country wanting to westernize but still in the process of yanking its identity away from its former patriarch.

"This is *still* such a cool place," I commented, recalling my previous visit.

"Haha—of course, dude."

As we tracked around the city that day, Serge and I peppered each other with questions.

"So what have the other kids on the exchange program been up to since I was last here?" I asked, looking up at him.

"Most have gone to university, like me. Others are still in Konotop with their families. We've gotten older, but not all that much is changed. And what about you? How is college?"

"Ah, it's all right. Lots of work. It's only supposed to get worse, but I guess that's what's supposed to happen when you grow up."

"Yes! We are all growing up!" he bellowed, clapping his hands.

"And what about Shannon?" he asked knowingly. "Is *she* grown up?"

His grin twisted into a leer as he looked down at me. I laughed.

"It's never gonna happen, man."

Trying to change the subject, I began listing places that I had remembered visiting from my first trip.

"Serge, do you remember the Lavra bell tower?"

"Of course. You want to go back?"

"Yeah. I think so."

"Well, we have nothing else planned, so if you want to go, just say so."

"Yeah, man. Let's go there now."

With that, Serge veered his course toward the nearest subway station, and down we plunged.

As we hopped into our second subway car, I felt two strong hands wrap around my rib cage. Wriggling around, I turned to see a massive mustachioed man looking at me with an expression of confusion and pity. As people flowed past us into the car, I struggled to gesture to him that I wanted back down. His arms full of me, he replied with a mixture of Russian and head shaking.

The man's eyes widened as my friend's voice boomed from behind. Serge must have said the right thing, because I quickly went from being face-to-face with the guy to sitting on the crushingly muggy floor.

As people continued to squeeze into the car, a sturdy woman approached and began speaking rapidly to us. The woman and I locked eyes just in time for her hand to shoot out and press my head back into the rivets holding the walls of the subway car together. As she spouted Yiddish, Serge shouted above the din, "She's crazy, dude! She thinks you're holy!"

"What?" I yelled as the wrinkled hands palmed my melon.

Serge shrugged helplessly. I could feel her hand, clammy and wet, pressing my forehead; the stale air blowing in through the windows; the dents being formed in the back of my scalp from the sharp rivets on the subway car's wall.

Why me? Of all the people on the train, what am I doing to deserve this? I paid for my ticket and got onto the car like everyone else, and here I am being dragged back into the limelight.

But is this doing any harm?
Aside from the rivets?
Aside from the rivets.
Is she enjoying it?
Might not be my choice of words, but yeah. She feels the need to do this, for some reason.
Then just let it go.

Finally, her hand eased off my forehead, and I unhinged my scalp from the metal studs. I looked up into her face, which was beaming as she switched to a Russian dialect.

Let it go.

The subway creaked to a shuddering halt, and the woman turned back to her own affairs, leaving us to wait for the deluge of people to subside before we, too, hopped off.

On my first trip to Ukraine, I had climbed the 239 tightly winding steps to the top of the Great Lavra Bell Tower and peered over the city of Kiev as a multitude of bells rang above my head. While looking out over the city with two of my schoolmates and Serge, someone grabbed me by the back of the shirt. As I turned around, I saw a black-bearded man in an equally black sweater tugging at my clothing. I followed him across the top of the tower and through a gated area, where he stopped beneath the ringing bells. The noise was ear-shattering, and he motioned to the man operating the complex web of bell lines to halt. The silence settled in for a moment, and the man looked at me.

"I will pray for you. Now you pray for yourself and your country," he said, as he spun me around to face out over Kiev once again.

And with another wave of the hand, the bell operator began again. I tried to move, but the man's hands came down firmly on my shoulders. For five minutes I sat, looking out over the city until the song finished, when I was yanked away by the bearded man. My friends appeared shocked as he led me out of the gated area. Once outside, the man produced a small jar of holy myrrh and proceeded to paint the oil on my heart, mouth, eyes, ears, and finally my forehead. It was another occurrence of being picked out from the pack of my peers, though in a more inspired way than on the subway train.

"Remember the priest who grabbed you?" Serge asked as we sat on a park bench and peered up at the massive structure. A sign stated that the need for repairs had closed the tower until spring.

"Yeah, and that oil he put in my ears."

"You got a blessing then, too. Maybe this isn't so strange."

I chewed on that line, but I still didn't believe it.

As we walked back to one of the main streets, Serge suggested, "This time, should we get a taxi?"

"Absolutely. I'll pay."

As we stood there, looking for an unoccupied cab to pass, a woman came up to us and kneeled down in front of me. Her face was contorted in grief as she held out a fistful of notes clenched between her arthritic fingers. She began speaking in Russian, and I tried shaking my head while mimicking Serge's pronunciation of "Uhmerican."

She looked up at Serge and began to speak as traffic rolled past. Again, I lost hold of the situation. Being unable to speak the language, I sat and watched the conversation escalate into raised voices. After a few exchanges, it was clear that she'd had enough of the squabbling and again knelt down to me. She stuffed two hundred hryvnias in the front pocket of my camera bag and walked off.

Let it go.

But I couldn't. The blessings were disorienting, but ultimately nothing was truly taken or given. It was something that I could tolerate. However, the ethics of being given alms was a heavy thing to bear. I didn't want this woman's money, and yet here it sat in my bag.

Making the situation worse was the amount of money. Two hundred hryvnias was about forty-five U.S. dollars, probably a week's salary to the woman. I didn't have much money, but I still had the comfort of knowing that, in a pinch, I could rely on my parents to help me out. But the proportional amount for a working Ukrainian woman was huge.

And that was the frustrating thing: I couldn't bring myself to feel grateful for what had been given to me. I didn't care about the amount; I didn't want the money. And ultimately, I didn't deserve the gift.

"What was that all about?" I grumbled as we got into a cab and peeled off.

Serge looked out the window. "She said something like it was in memory of her daughter." Quickly brushing aside the implied tragedy, he smiled, "It's just our mentality. Ukrainians are very generous. Even if they can't spare the money, they'll give you the last they have."

"Yeah, but why didn't she give *you* money, then? Why me?" I raised my voice as the driver's eyes flashed in the rearview mirror.

Serge turned to me, squaring his shoulders. "Try to understand. You are handicapped. In our country, I haven't seen one handicapped man walking down the street like a normal man. They are usually begging. You see them everywhere, and lots around the subways. Some people even have a business. They have like ten handicapped people and put them in a subway station to beg for the day. In one day, a person can earn five hundred to one thousand hryvnias. That's it."

He punctuated the explanation with a flustered tone. It was clear that my frustration was starting to rub off on him. I looked down at my hands, stunned.

"So people think I'm a beggar."

"Only sometimes, but yes, something like that."

To be honest, I had never thought about it in that way. Sure, I had my doubts and curiosities about traveling as an American in Europe, or as a guy who only spoke English, but I had never thought that my simple presence *anywhere* would generate both blessings and offerings. Minutes later I was handing over my alms money to the taxi driver, the hryvnias feeling greasy in my palm.

We stepped out of the cab and began walking through the cluttered courtyard that led to Serge's apartment. Serge lightly tapped me on the top of my head, trying to lift the mood.

"It is okay, Kevin. Tonight we go out and drink. It is a student holiday. We will find a disco, meet some girls, and drink many drinks!"

That evening, we found ourselves standing on a dark, narrow staircase, packed with forty other students waiting for the local discotheque to open. As we waited, I caught the silhouettes of two-liter Coca-Cola bottles being passed above me. Serge grabbed one of the bottles and knelt down to my height.

"Here, you try it," he said, pushing one of the bottles under my nose. The contents smelled like lighter fluid poured into coffee grounds and left to bake in the sun. I took a swig of the lukewarm drink and gagged. The taste wasn't that far off from the smell.

"This is one part coffee, one part cola, and one part vodka. We call it 'Black Nails' or 'The Alarm Clock.' The name depends on how much vodka you put in." He smiled and swigged again. I sat there, letting the taste of Nails roll around in my mouth.

Finally, the doors opened, and we joined the rush of kids into the hall. It was the size of a small classroom and still had the locker room smell of the last dance party. I crossed the sticky black floor and sat in the corner where Serge had found a booth. I piled behind the table and stared at the cups of vodka already waiting there.

Serge grabbed me by the shoulder and shook me, Nails steaming from his breath. "Kevin, you must have more fun. Relax, dude," he said, laughing, and knocked back his cup.

That night, as I let the drunkenness set in with the loud music, I resolved not to let the stream of strange reactions get to me. It didn't matter what people thought; I was still me. "Hell with it," I muttered, throwing back the vodka.

Sign language would've been more effective than the sparse, broken conversations that I had with some of the Ukrainian students next to me. But between the pounding Russian techno and my magically refilling cup of vodka, conversation wasn't all that important. All that I needed to fit in here was to be willing to drink and to laugh. Both were needed.

Once again I sat waiting in the Kiev airport. My stay in Ukraine was over, and I was departing in an hour for a flight to Austria. Serge began to mist up at the security checkpoint. He was a good friend, and I would miss him. It was tough seeing him choke up; between all of the posturing and "dudes," he was a really great guy. I felt sad, too, because I didn't know when we'd get to see each other again. After a quick hug, he turned and left without looking back.

As we circled upward into dark clouds, I began to get excited about my next destination. As fun as my time with Serge had

en, the reactions I'd been subject to had taken their toll. All of the guilt and irritation I'd felt about receiving money or being blessed still lingered, and I wondered if I would receive the same treatment in Vienna.

Silently, I promised myself that no matter what, I'd do my best to keep a smile on my face. I knew that if I focused hard enough, I could keep those reactions from bringing me down. But I also knew that fifteen thousand feet off the ground, removed from the realities of the street and public, was also the easiest place to fool yourself into thinking the impossible.

SNAPSHOT

Prague, Czech Republic

I t had been pouring since my arrival in Vienna, and after booking a small bunk in a nearby hostel, I'd spent the rest of the afternoon answering e-mails and generally hiding out from the public, my memories of Ukraine still fresh in my head. I thought that if I headed out during the night, I'd be subject to a lot less attention than sightseeing by day.

Examining my small, dog-eared map of the area, I saw that a major shopping street named Mariahilferstrasse would lead me straight to the historical center of the city. So I loaded up my camera bag for what I hoped would be a few hours of night shooting some of the local hot spots.

The street was almost empty as I let my board pick up speed on the long downhill slope that began just outside the hostel, my wheels making rhythmic *thunks* between the concrete tiles. The neon light from the shop signs blurred by my eyes as I swept past the few people walking in the dark. I had just passed a streetside bratwurst cart when someone shouted.

"ALLO! HALT!"

My duct-taped gloves slipped along on the wet concrete as I struggled to stop at the command. I thought that I was being yelled at to slow down. I expected a police officer when I turned, but instead I saw a portly man plodding toward me with

heavy, wobbling steps. He wore a baggy coat and dirty jeans that I could see were soaked as he dropped to one knee in front of my board.

He began speaking sloppily in German, his mouth full of greasy pork. I'd taken some German in high school, but the Austrian dialect and a mouth brimming with food made his speech unintelligible.

"Uh, I'm sorry, I don't understand," I said.

He cocked his head to the side, like a dog seeing something strange for the first time. "You're American," he said, reaching into his coat. "Well, I have something for you."

When he pulled out his wallet, I'd already begun to shake my head "no." He didn't pay me any mind and pulled two bills from his wallet. "Fünf und zehn," he spat, ostentatiously slapping a couple five-euro notes into my hand.

"I don't need the money!" I said testily, fumbling in frustration to justify myself. "I'm just riding this board for the—"

"Na na na na. I do not care what you say," he interrupted as he closed his billfold and began reaching into his pocket. He produced a handful of coins and began dropping them from his hand to mine with all the drama of a street magician. With his voice raised, other people on the street began to stop and stare. Even the sausage cart owner was peering over his counter to get a glimpse.

He stopped with a loud declaration of "funfshehn! Now you have money and a sausage."

I didn't know what to say. All I managed to do was plaster another pathetic grin across my face. It was a different kind of beating than the one I'd gotten from Trevor all those years ago, but the embarrassment was the same. I should have thrown the

money on the ground or skated off, but my spine went weak, and instead I squeaked out an embarrassed "thank you."

The man stood up and waved goodbye, before turning back to the bratwurst stand. I was still there, only a couple yards away from him, but suddenly he was ignoring me. I knew he could speak English, and that he was doing nothing more than finishing his piece of greasy food back at the cart; but his interest in me was limited only to the point of alms giving. I was something to be dealt with, packed away, and this time I had no one to whom I could vent my feelings. Serge wasn't here to explain it away or lift my spirits. I didn't spend much more time out that night, and as I slowly plodded the long, uphill return to my hostel, I stewed in my own anger.

Thank you? Thank you!? That's all you could say? What the hell, Connolly. If you're not going to do anything but plaster that smile on your face when someone does that to you, maybe you should just stay inside.

My anger doubled back in on itself when I got to the hostel and plopped my soaked body into the lower bunk in the corner of my shared room. As I watched a couple of half-boozed Australians saunter in, I reprimanded myself for letting the paunchy guy get to me.

If you stay mad at this, you're going to waste the trip. People aren't going to stop doing this, so if you let one get to you, then soon everyone will, I thought as my eyes drifted shut, my parents' past lectures echoing in my head.

I woke up the next morning around six. It was dark out, and the Australians next to me were still asleep. I snuck down to the cafeteria built into the hostel and ate a slow breakfast, not savoring the food so much as trying to drag out the process of eat-

ing—anything to delay having to go back out onto the streets.

When I returned to my room, the Australians had left, and the sun was out. Even as I lay back down on my thin mattress, I could feel guilt welling up in my chest. I knew that I almost had a responsibility to go out and enjoy myself, to keep my time here from being wasted.

"Suck it up," I kept muttering to myself. An hour passed. Then two. By the time I stepped outside, camera in hand, it was well past ten in the morning.

But the hours lying in my room hadn't been totally wasted. I had figured something out. Every time that one of these interactions had occurred, I'd been stationary: waiting for a taxi, sitting on the subway, or stopping at someone else's request. It was only during these moments that I was thrown into these embarrassing situations.

As I let my board gather speed on the hill of Mariahilferstrasse for a second time, I resolved not to stop for anyone.

As long as I keep moving and don't stop, it'll be okay.

So that's what I did. Weaving in and out of crowds, I kept my focus on the pavement in front of me. I didn't look around, I didn't make eye contact, and I didn't stop pushing. By the time I'd made it to the end of the street and into the wide courtyards surrounding the Hofburg palace, my shirt was damp with sweat.

When I arrived, I saw a crowd of hundreds. The Christmas markets had been erected almost a month before the holiday, and swarms of people flocked between the various food and drink stalls dividing up the walking space. People were packing into the narrow lanes, and I was forced to severely slow my pace. I knew it was only a matter of time before I'd be seen. I kept my head down and tried to focus on the worn, black grip tape on the

top of my board when I heard a tinny click behind me. I turned around to see five teenagers giggling behind gloved hands. Two held their cell phones up in front of their face, snapping photos.

"Really?" I said out loud, as they began to scatter, trying to avoid being called out. I'd had people sneak photos of me before, but what really offended me was the fact that they used their camera phone. I was just something shocking on the street; a grainy photo to send their friends. Who knew where that photo went or how many laughs were gotten out of the image?

But by calling them out, all I'd managed to do was draw more attention to myself. Now that my face had turned upward, away from the ground; I started to realize that it was more than just the five teens. Everyone nearby had begun to stare. Real anger—the sort of emotion that makes you puff out your chest and clench your jaw—burned in my gut. I bullied my way through the crowd until I'd escaped the crowded market and found myself on the narrow backstreets behind the palace.

I pulled out my camera for something to clench as I kept skating. I'd stopped bothering to look at my map and decided that I'd just take pictures of whatever came my way. I knew that the large, more famous monuments would be streaming with people, and I didn't want to slow down again.

It was late afternoon, and I'd managed to avoid people fairly well when I saw a man rounding the corner at the end of the block. He was coming toward me, and even from a distance, I saw his pace slow. His steps stuttered for a moment as he did a double take. Still fuming from my earlier encounter, I did something impulsive. I looked across the street and tried to keep my eyes from meeting his. My right hand still had a white-knuckle grip on my camera as I held it at my side, floating mere inches

off the concrete, and I hoped he wouldn't notice the lens slowly aiming up at him.

C'mon, keep looking, I thought, listening to the sound of his footsteps and trying to gauge the moment when he'd pass. With the camera at my hip, I pushed the button and heard the muffled *chik-ticht*. I didn't have any idea what the photo looked like or if I'd even managed to capture him, but it didn't matter: I'd used my own form of staring.

After a celebratory dinner alone, I made the long skate back to the hostel. I'd lost my way in all of my earlier frustration, and by the time I'd arrived, it was dark. The other travelers in the room had already gone out for the night, and I huddled into my corner and began sorting through the photos from the day. Most of the pictures were tourist shots of buildings and scenery, travelogue sort of stuff that I planned on boring my friends with when I got back to Montana.

It wasn't until the photo of the man came up that I stopped. What I saw was unlike any photo I'd seen before. The lens was barely hovering off the ground, with a full third of the image taken up by the concrete walkway. The angle was dramatically skewed and showed a distorted, towering world, in the center of which was the startled man. The look on his face was a blurred combination of curiosity, worry, and shock. As I studied the image, a sense of vindication and excitement hit me. Technically, the photo wasn't that great, the colors washed out, and the image blurred from the motion of my skateboard, but it hinted at something larger.

The next morning, I set out on the board, covering the same route I had the day before to get me into the city. This time, though, I was actually looking for the same crowds and faces

that would inevitably ogle me as I passed. When I arrived back at the Christmas markets, I immersed myself in people, never looking in the direction my lens was pointing. I'd wait for the feeling on the back of my neck, the one that lets you know someone's staring, and I'd secretly fire off a shot from my hip.

chik-ticht
chik-ticht
chik-ticht

Each photo was a miniature catharsis—only a fraction of a second that lasted about as long as the shutter speed on my camera. I shot for the rest of that day, and each picture began to add up, the moments turning to seconds and then to minutes as my day slowly filled up with a sense of victory, and perhaps even vengeance. One day turned into two, then slipped into a week. I continued shooting when I landed in Ireland, my next stop, going out every morning and shooting until dusk settled. Nights I spent trying to edit the photos taken during the day, deleting the ones too blurred or badly framed to be usable.

By the time I was boarding the flight back to the States, I had racked up nine hundred photographs of men, women, and children from two different countries looking at me in exactly the same way. I'd shot beggars, school kids, couples, and even one very shocked-looking priest. When I viewed the images on the screen, each of my subjects appeared identical, if only for a moment. That curious glance was linked, from person to person, across the spectrum of age, money, culture, or anything else.

There was something empowering in taking those photos; realizing that I created such a universal effect on people. The

feeling of power stemmed from the feeling that I could go almost anywhere in the world, and while people's reactions may be unpleasant, they would always be predictable. Until now, being stared at had been a frustrating—but unpreventable—burden that I had to bear with a grin. Finally, I was able to find my own use for that stare, and it felt good.

My plane landed in New York City, where I had planned to spend a week before finally heading home to Montana. My burgeoning photo project still consumed me, and on my first full day back in the U.S., I headed into Manhattan with my camera. Riding the bus from my aunt's house in the Bronx to the center of the city, I began to wonder about how New Yorkers would react to me. In a diverse city of over eight million, I wondered if I would even stir notice in such a melting pot.

One block from Grand Central Station, I stopped at the corner with a group of people waiting to cross the street. A traffic light had gone out, and there were police officers on every crosswalk trying to direct the milling vehicles and pedestrians. I had just pulled out my camera from its dirt-stained bag when the policeman standing next to me noticed for the first time that I had stopped beside him. Looking down, he jerked with fright.

"Whoa! What the *fuck* happened to you?!"

Before I even looked up to answer the question, I smiled.

chik-ticht

GOING FOR BROKE

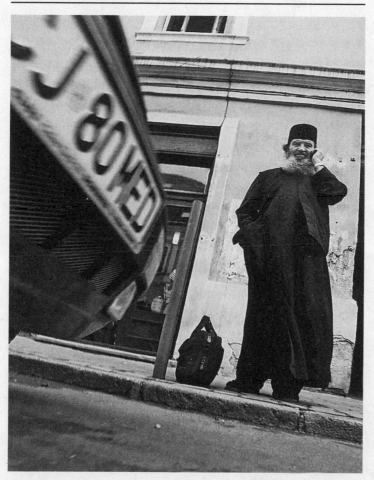

Cluj-Napoca, Romania

FIFTEEN SECONDS!"

A funny thing happens just before the start of the X Games Mono-skier Cross, held every year in Aspen, Colorado. A multimillion-dollar event, the X Games draws the top athletes from around the world to compete in extreme winter sports and dominates national television for the week that it runs in January.

The cameras above you, hung from zip lines that run the length of the course, begin to fire up their electronic motors. If you listen closely, you can actually hear a distinct, mechanical whine. Imagine the sound a remote-controlled car makes when it's held up in the air with its wheels spinning. Now place the sound of that mechanical whine above your head and infuse it with the knowledge that it is a portal through which millions of people are watching you compete.

The Mono-skier Cross, or "Mono X," as it is known in commercials, is a competition in which your goal as a disabled athlete is to beat the other four racers beside you down to the bottom of a gated course. En route, you will encounter obstacles and jumps ranging from five to ninety feet. Injuries are common; wrecks are more so.

Since you're sitting on a $3,000 piece of equipment that is going to determine both your safety and success for the next four minutes, it's important to perform a mental check.

On each hand, you should have what is called an outrigger. An outrigger looks like a hospital crutch if you were to cut off the lower twelve inches of aluminum tubing and replace it with a shortened ski. The ski can flip up, allowing you to push yourself along the snow, or flip down to provide balance. If you are missing these two pieces of equipment, now might be the time to reconsider your decision to compete.

Directly below you should be an alpine race ski attached to a snowmobile shock and a collection of thick, powder-coated aluminum tubing, or mono-ski. This mono-ski allows someone with a disability—whether it is a spinal cord injury or leg shortage—to ski safely and competitively with able-bodied skiers. If you were to look at the profile of a mono-ski, you would see that the aluminum tubing closely resembles a person's legs when they are in an active crouch. The shock, finely tuned to your weight and ability, is there to act as a skier's leg muscles, absorbing the abuse that comes with sliding down an icy slope.

"FIVE SECONDS!"

Your heart rate begins to imitate the mechanical whine above your head. Your breath lurches, and suddenly you realize that you desperately need to evacuate your bowels. This is a feeling that needs to be suppressed for three reasons. One, it would make the physically draining task ahead extremely unpleasant. Two, shitting yourself at the starting line might imply an early, if not preordained, sign of defeat to your competitors. And three, the fact that you are locked into a fiberglass bucket that reaches above your navel renders the process of defecation physically impossible.

Then the gates drop and a wall of sound pounds its way through your helmet. The racers to either side of you grunt and yell as they push off the starting blocks. The officials behind you scream, "GO! GO! GO!" and the roar of hundreds rumbles up from the bottom of the hill.

But at that point, you probably won't even register the noise.

I received the invite to compete in the X Games only a few hours after I returned from New York. After exchanging a round of hugs with my folks, my eyelids began to droop. The excitement of coming home had passed, and suddenly, more than food or conversation or anything else, I needed a bed.

I thought I was still dreaming when I felt a hard tapping on my chest and Shannon's voice commanding me to get up. Still exhausted, I rolled over and muttered "go away" as I tried to force myself back to sleep.

Shannon grabbed my shirt and twisted me toward her. "You have a phone call, so get up right now." I hadn't expected that much strength from my youngest sister, and the sound of threads snapping in the collar of my shirt brought me to attention.

I hobbled over to the phone, my eyes half-shut, and put the earpiece up to my head.

"Hey, Kevin, it's Kevin Jardine here."

I perked up a little. Kevin Jardine was the former head coach of the U.S. Disabled Alpine Ski Team, a group that I had aspired to be part of ever since I first began racing. I'd come close to being invited but had never been officially accepted. Despite Dad's monumental efforts at getting me around the country to race, we simply didn't have the money to attend more than two or three competitions per season, and thus never accumulated the points or presence on the slope that would get me noticed.

While my early racing career was marked with the success of three Junior National Champion titles, as well as a slew of other medals, my later years were not nearly as winning. High school had begun to take up more and more of my time, and with it, my chances to compete.

The races that I did manage to attend, I did very well at, usually racking up a top ten or sometimes even a podium finish. But just like any sport, if you don't make it to enough games, you're never going to be on the team. So after six years, thousands of dollars, and countless miles spent chasing a goal that always seemed just out of my grasp, I quit racing at the age of nineteen. I was sick of spending all of our time and money chasing a goal that I felt I'd never truly achieve.

So I gave it up. I figured that if I wanted to be able to afford going to college and trying to travel to New Zealand, there wasn't any room for burning money on competition that never paid back. So I began to ski for fun. Instead of having the accumulated pressure of competition, travel, and finances weighing on my mind, I'd spend the weekends skiing wherever I chose at Big Sky.

When I heard Kevin's calm voice on the other end of the line, I almost wondered if he'd dialed the right number—that was, until he started in with his proposition.

"Hey, I wanted to let you know that X Games wants to host an event for disabled racers this year, and they've asked me to pick sixteen racers to compete in the Mono-skier Cross. There's going to be some big jumps, but you'll be competing on live television, and there'll be money on the line."

I sat there for a moment, stunned. I had been home for only

five hours and was still trying to wake up from my nap, hardly enough time to really register what he was offering me.

"You in?" he asked, snapping me back to reality.

"Uh, yeah. Definitely. I'll do it."

"Good. The comp's in Aspen on the last week of January. You'll be racing on the same skier cross course as the able-bodied guys, so you'd better get training," he said, clipping my answer short. I was choking back an excited scream as we said our goodbyes. The opportunity to compete at such a high level was an honor and implied that the coach had at least *some* faith in my abilities. It was validating to still be on his short list of people to call if they needed top-end racers to compete in a high-stakes race.

By the time I hung up the phone, I was already shouting, "I'M GOING TO THE X GAMES!" at the top of my lungs and dancing around the room. Dad came down the stairs and stood there.

"What was that all about?"

"I just got an invite to compete in the X Games!"

Dad leaned against the wall and gave me a smile.

"Congrats, bud. When is it?"

"Next month," I said.

Dad looked down at the carpet and nodded. "You've got a lot to do. It's been a year since you've really skied. Think you're up for it?"

My stomach sank a little. I'd seen the courses that were regularly built for the X Games skier cross. I'd seen the type of courses Kevin was talking about on television, and I'd also been witness to some of the wrecks and injuries that happened

if a racer made a mistake. Well-trained, experienced racers destroyed themselves regularly during the event, and I had no doubt that the Mono-skier Cross would be any different.

"Have you seen your gear yet?" Dad asked, doubt growing in his voice. "It's still covered in your blood. You'll have to wash that off before you do anything else."

"Where is it?"

"Your ski and gloves and stuff? Oh, it's down in the basement."

When I made my way into the dark, unfurnished cellar that we had converted into a ski shop, I could still smell the synthetic scent of years of melted ski wax that had baked itself into the walls of the room. Flicking on the light, I saw my pile of equipment lying haphazardly in the corner. I had hastily thrown it there almost a year ago, before I left for New Zealand.

When I got closer to my mono-ski and outriggers, I could see splotches of what looked like red dust covering the aluminum. The year-old blood was everywhere, covering the inside of my ski jacket and every inch of my gloves. The rust-colored stains served as a visual reminder of the last time I'd been skiing.

On one of my final days before my trip, I had gone out on the slopes with Ben, an old coach and ski buddy of mine. Ben had been introduced to me by Buck, my first skiing mentor. Ben and Buck were best friends and coworkers, and when I first saw the two standing together, I almost mistook them for brothers. They were both short, red-haired Dirtbags who spent as much time as possible outside on the ski hill.

After I quit ski racing, Ben and I began to spend more time together cruising around the top of Lone Peak at Big Sky. Our usual haunt up on the 11,000-foot range was on the south-facing

slope that provided steep, exposed faces of the mountain and some of the best off-piste skiing in the country.

It was up there, during a particularly nasty blizzard that had shut the tramcar down behind us, that I was given my first real taste of the consequences that can go along with extreme skiing.

The wind had eclipsed sixty miles per hour, and the blowing snow blinded us as we tried to feel our way down the mountain. Ben and I were trying to wrap around to the south side of the hill via a rough, narrow track, when a forceful gust caught us and sent me toppling off the trail. Everything went white as I flipped headfirst into the snow and rock below. On my second somer-sault down the hill, my face landed on top of an avalanche fence post, and I heard a distinct popping sound in my jaw. I quickly wrapped my arm around the post and lay there for a minute in shock.

The avalanche fence was the only thing keeping me from a long and painful tumble down the steep, shale mountainside. Up above, I could see Ben kicking off his skis to come down and help untangle me from the wooden boards. I held my glove over my mouth, which I could feel pulsing and unnaturally warm. I pulled my glove away just as Ben got to the fence and saw that it was covered in blood.

"You're a mess! What the hell happened?" he yelled above the deafening wind.

I was already having a tough time remembering what had put me into the fence and looked at him dully.

"I stchink I knockt out a toof," I said, hearing a grinding sound in my ear. I ran my tongue across the row of my lower teeth and felt an inch-wide gap just left of my central incisors.

"I did knock out a toof! Unnnngggg," I grumbled, half in

anger, half in pain. My mouth was full of liquid, and I spat a bright-red burst of color into the snow. The snow absorbed the blood and radiated it out in all directions. I sat there looking at it for a moment before Ben shook me.

"The tram has been shut down, so no one's coming. Can you ski?" Ben asked as he grabbed me by my coat collar, lifting me off the fence post. I sat up, still buckled into my mono-ski, and looked at him for a minute.

"I knockt out a toof," I repeated like a crazed mantra. My eyes were having a tough time focusing, and my peripheral vision was starting to blur. I tried to look directly at Ben through the sepia tint of my goggles.

Ben was hunched over, trying to keep the ripping wind from knocking him over as well. His thick red beard was covered in ice that shook as he grabbed me by my jacket. "Yer bell's been rung. We gotta get outta here. Come on!"

As we picked our way along the fence in the blinding snow, my perception of time and identity slipped away. When we made it to the trail, I tapped Ben's back with my outrigger.

"Ben, where are we?"

"Oh boy. You're losing it. Focus on me for a second."

"But why are we here?" I asked, my eyes rolling wildly in my head. Ben shook my shoulders, and I was able to concentrate feebly on what he said.

"Listen. You have to ski out of here. No one can help you until you get to the bottom," he said. His voice sounded like a slowed-down record, deep and distorted.

I nodded, and as I turned my ski downhill and began to pick up speed, I blacked out.

When I came to, I was being x-rayed in the Bozeman Deaconess Hospital, a two hours' journey from the avalanche post. My jaw had been severely broken in two places, and they had scheduled me for surgery the next morning to wire my mouth shut. When I flew off to New Zealand a few weeks later, I was on a liquid diet, the metal wires that held my jaw together still winding their way through my mouth.

Knock it off, I thought now as I gathered up my dirty gear, months after the surgery and recovery. No one—not Dad or Buck or Ben—would want to hear my whining or self-doubt about surviving the X Games, so I tried to force the memories from my head as I ran my tongue along the lumpy scar tissue across my gums. I knew what the phone conversation would be like with them: phrases like "Suck it up," "You're in it now," or Ben's staple, "Don't be a such a pussy."

It wasn't that these guys lacked concern for my safety. Ben had helped me down the hill and had stayed with me through my short stint in the hospital. He'd called Buck and my dad, and I'd seen all of them within a day of my accident. They simply couldn't be bothered with vocalized fear or self-doubt. I wasn't going to get their attention or sympathy until I was broken and bleeding on the hillside—even then, it would be a tough sell.

Promptly after Christmas with the family, I loaded up my worn-out Oldsmobile with some clothes, a wok, and my ski gear and moved back to my home university of Bozeman. Over the next four weeks, I spent as much time as I could up at Big Sky, sharing space with other racers on the mountain and trying to regain the confidence that I had lost in the accident the year before.

I trained hard for the short period of time that I was given, but even as the van wheels rolled south toward Aspen a few nights before the competition, I still didn't feel prepared. The doubts reiterated in my mind right up until the first heat of the competition.

I haven't trained enough. I haven't pushed myself hard enough. My gear is too old. I don't have the right ski. I'm the only guy not on a national team. I'm one of the few nonracers on the list. I'm an underdog, a dark horse, a long shot.

It wasn't until I was standing at the top with the tip of my ski pressed up against the starting gate, that Ben's, Buck's, and my dad's collective response echoed in my head.

So what? Go for broke and see what happens. Screw everything else.

I heaved myself out of the gate with a massive push, unaware of what the competitors on either side of me were doing. I got the lead early, and for the entire first quarter, I was surprised by the empty course ahead of me. Then I saw the flash of a pink jersey passing me on my right. The fluorescent jersey belonged to a U.S. team member who was favored to win the competition, and while I wasn't surprised at his lead, I tucked my head down and did everything I could to catch him.

But I couldn't. I held my second-place position, always close behind him, but never near enough to pass. When we rounded the final pitch and the finish line came into view, I knew I wasn't going to catch him. I made it down and locked in my second-place finish—an accomplishment that came with money and a medal.

After the craziness of the awards ceremony and interviews

had ended, I went and sat in the van for a quiet moment to rest. I rang up Dad, Buck, and Ben in order, one at a time, to give them the good news. Buck and Ben had stayed behind due to work commitments, and I had asked Dad to remain at home for this race. The reason for my request was that I didn't want the pressure of having a close friend or family sweating over my every move during the event. I also knew that if I did get hurt or blow out of the race, it was a lot easier to explain in a phone call than in person. But most of all, I didn't want to fail—to lose—in front of someone who had put so much time into my success.

My fears were unneeded. To a word, everyone asked the same question.

"You go for broke?"

"Well, yeah," I responded, trying to figure out what that phrase really meant.

As I hung up the phone, I kept chewing on the line. Maybe "going for broke" was one of those goals you set for yourself, yet hoped never to achieve. It was one of those perpetual states that you wanted to maintain, because actually achieving "broke" could mean smashing your face into an avalanche post.

Going for broke meant pushing the boundaries of what you considered safe or healthy, in the face of something that you'd never done before. Going for broke meant tightening your sphincter at the starting line and deciding to race regardless of the consequences.

And while going for broke was what probably netted me that silver medal, it reached further than just one competition. It was the attitude held by most of my buddies back in Bozeman, and while I was sure to get some slaps on the back for my accom-

plishment, the praise would be short-lived. The ski season was just beginning, and I still had work to do if I wanted to keep up with Ben on the hill. I knew he'd push me, make me go to places just past the edge of comfort and keep me there. And besides, I had to get back up to the top of the mountain. I had an avalanche post that I needed to carve my name into.

MONEY MOTIVATIONS

Sighisoara, Romania

I sat in my old blue sedan, holding a ringing cell phone to my ear as I watched my breath condense and freeze on the inside of the windshield. The car had been given to me by my grandmother after she passed away, and I'd been driving it since shortly after my performance at the Vigilante Parade. The defroster had broken a few days back, which only added to the general state of disrepair of the car. The tires were bald, and the front wheels spun wildly through the snow-packed streets of Bozeman. The plastic panel on the interior of the driver's side had fallen off, leaving no way to open the door. The only way to exit the vehicle was to climb across the seats and get out through the passenger's side.

Worst of all was that the electric windows were broken, so not only was it impossible to defrost them, but I couldn't open the door to vent my breath, which was icing up every window in the car. So I tried to control my breathing as I dialed, holding in as much air as possible, before the click of the phone and the sound of my dad's gruff "hello" forced me to speak.

"Hey, it's me."

"Whaddya need?" he barked.

I tried to imitate his brevity. "Nothing. Just decided what I'd do with the money."

There was silence, then a sigh. "Here. I'll pass you off to the boss."

I could hear him shouting Mom's name as he bumbled through the house, and I kept running over the speech in my head.

When I first showed the photographs that I had taken in Europe to my parents, they were supportive but nonplussed. Dad looked at the set—edited down from twelve hundred to approximately twenty images selected from Vienna, Dublin, New York, and Boston—and laughed.

"Shit, Kev. We've been seeing that your whole life."

He was right, of course. Long before I became aware of these gazes, Mom and Dad had endured decades of unwanted attention.

"It's been pretty tough to keep myself from smacking some of these folks over the years," he said, as he flipped through the collection. "But eventually I got worn down. I just couldn't let myself get pissed about it all the time. I kinda forgot, actually."

What he'd forgotten, I was just starting to figure out. For the first month I had the photos, I looked at them almost every night. But once the honeymoon period ended, I began to look at them in a new light. Specifically, I began to realize how poorly shot and limited they were. The subjects were blurry, and if they weren't blurred from the movement of my skateboard, they were distorted by my old digital camera.

The process of shooting each image had been therapeutic; a way in which I could vent my frustration about all the reactions I'd been subjected to while on the skateboard. But when I'd been shooting in Vienna, I was more focused on my own personal catharsis and passive-aggressive form of vengeance than on how the photos turned out. I'd shown the images to a few of my photography professors during the first days of semester registration,

and the feedback was almost universal: the concept might be there, but the images sure as hell weren't.

Furthermore, I felt disingenuous whenever I pitched the idea to someone new. Stating that everyone in the world will stare for a split instant, regardless of their age or where they're from, is a good notion, but I didn't really have enough evidence, both in terms of countries and photos, to really back it up. What the project needed was magnitude. To prove that everyone did this, I needed more travel, more photos, and more reactions.

The biggest shortcoming of the project was, in many ways, its lack of connection to me, personally. People stared all the time. I'd looked at people my whole life—and not just others with disabilities. I could have been an able-bodied guy who plopped down naked on the sidewalk and took photos similar to these. So outside of my own need to deal with this phenomenon, there was no strong connection between the project and me. I was aware that people stared at me—I'd been surrounded by this collective reaction for twenty-one years—but what did those looks *mean*? What did they say about the other person, and how did that affect me? Those two questions nagged at me. I knew the basic answers: people stared because they were curious, and sometimes the attention really frustrated me. But it felt like there was something deeper than that, and I knew the only way I would find the answers would be to go back out for another round of travel.

Even with twelve hundred or so images, I had the sense that the series wasn't fully formed, and that I hadn't fully explored what all these double takes really meant. Even as I trained for the X Games, even as I drove down to Aspen, and even as I tried to keep from shitting myself at the starting line, I knew what I wanted to do with the money if I won.

So when I finished the race and was cutting back north through empty expanses of Wyoming, I was already starting to dream of the places that I would fly to and the gear that I would need to pull it off. When I got back to Bozeman, school had already been in session for a few weeks, and I rushed to catch up on all of the work I had been missing. Between classes, I hurried to complete student loan and university grant applications. All were approved.

As I sat on the floor of my unheated apartment, nursing a glass of wine and checking my online bank balance, I should have felt a sense of triumph. I had just over $7,000 in my account, which was by far the largest sum of money I'd ever possessed. Even if some of it was on loan, that money was mine, and I was using it to continue working on a project that for the first time had made me think about the reactions I'd been subjected to all of my life. But instead of going out immediately to buy plane tickets and a new camera, I let the money sit. Most nights, I'd pull up my online account balance and spend a few minutes just looking at the sum.

I had talked to Mom earlier in the week and told her excitedly how much money I was going to have in my account. I don't know why, really. Maybe because my first taste of sweet, sweet capital felt pretty good, and I wanted to brag a little. When I told her the sum, she responded.

"Wow, I wish I had that much in my bank account," she said jokingly. We both knew the truth behind it though, and I said "Sorry," almost as a reflex.

"You don't have to apologize. It's your money," Mom cut in, her tone not losing a bit of pleasantness.

I shouldn't have brought it up, I thought.

(cleanup)

Mom and Dad had always been working-class people. Dad had come from an East Coast family who had largely done well for themselves, but he'd forsaken any higher paying career opportunities to live the lifestyle that he wanted in Montana. He had met my mom while working as a bartender in Helena, and after eighteen months, they were married. Instead of a honeymoon in the Caribbean or a cruise, they took a weeklong camping trip seventy miles outside Helena.

Dad worked as a chip deliveryman for Frito-Lay until I was seven years old. He usually came home after dark; I remember one winter night specifically. He walked in the door with a limp and promptly sprawled on the couch in our living room.

Normally when Dad got hurt, he became angry or frustrated. He'd curse at the folks around him, sometimes as if they'd caused his pain. Instead, he just sat there, barely saying anything except to Mom, who quickly hustled us into our rooms for an early bedtime. It wasn't until the next week, after he'd gone to the doctor, that Mom explained that he had blown out some disks in his lower back and torn his rotator cuff almost in half.

It wasn't until the second year passed and I turned ten that some of the stuff that Mom and Dad spent their nights talking about began to make a little sense. I knew that Dad couldn't work and that Mom was trying to find a job, but I also heard them discussing lawyers and "workers' comp" not paying out.

As we got older, they began to tell us more about their financial situation. Every couple of weeks, Mom would spread out a bunch of bills and move them dizzyingly around the wooden table in our kitchen. Meagan and I would stay up late some nights, sitting at the table with her, which was when she began telling us about finances. She was open, but she never let us see her become truly upset.

"It's paycheck to paycheck, dear. Five hundred dollars comes in and then goes right back out," she'd comment. "They say money doesn't buy happiness, but lack of it can sure create a lot of stress."

Still, we were hardly the picture of poverty. We always had enough to eat, though it meant Mom spent a bit more time clipping coupons and driving around town trying to use them. Dad managed to get his shoulder operated on and even showed us the series of staples that the doctors had punched into his shoulder to keep the wound together.

After that, he was able to get around the house a bit more. He even began taking advantage of his old college degree and started substitute teaching around town. He couldn't get work for more than one or two days a month, so most of the time he spent home with us.

When aunts and uncles neared retirement and began discussing exotic vacations and places they wanted to travel to, my parents went silent. Our vacations were either camping or river rafting—activities that were cheap or free for a family of five. The only exception was the occasional visit to my dad's parents in Connecticut. We tried to make it out every other year, but since we couldn't afford plane tickets, we became used to driving from Montana to Connecticut in the van. Mom usually stayed behind to keep working as a paralegal at a small family practice law firm, but with Dad's occasional construction and teaching jobs, he was able to take a month off almost every summer during our school break.

It was during this period that I began to take an interest in ski racing. Dad, already unemployed, decided to stay that way and sacrificed any chance of future financial security in order

to make sure that I got some confidence and happiness through the sport.

To keep us afloat, he began draining his retirement accounts, cutting them nearly in half by the time I'd reached high school. "We'll work till we die," he said, "but that's all right. Hell with it." I never really understood what they gave up for us kids during that time, but now I began to resent myself for not being more aware.

As we got older, Mom and Dad became even more open about their financial situation. I wasn't going to get much, if any, help with college, simply because they couldn't afford it. So in the months leading up to my high school graduation, I spread out my own set of papers—loan and scholarship applications— across the kitchen table.

Their frugality had rubbed off on me, and now, with my new X Games money, I felt as if I needed to do something more responsible than working on a photo project. The more pressing needs to save for the future, pay off student loans, or make badly needed repairs to my car, all reared their heads as I considered my options. I began to second-guess my decision, and expected Mom to do the same, as Dad hunted for her on the other end of the line.

"It's your son," I heard as Dad handed the phone to Mom.

"Hey, honey."

"Hey. I'm going to spend my money on travel and shooting and the project," I blurted out. I quickly tried to further explain myself before she had the chance to interject.

"I don't think that the photo project is done yet, and I can't say my idea applies to people all over the world unless I go to more than just a few countries. And I'm really sorry, but I'm not going to pay off my student loans or fix my car or do anything

else. I know it's irresponsible, and I probably shouldn't be doing it, but I've already decided."

By the time I'd finished with the long, gasping string of reasons behind my decision, my windshield had gone opaque with frost. I expected there to be silence; maybe she'd sigh or cluck her tongue.

"Whatever you want to do, Kev, I think you should do. Go for it."

Oh. I hadn't expected that. Instead, it was me who was silent. I had almost hoped for a debate. I almost *wanted* to hear that it was a stupid decision, that I should stay home and pay for the things that would keep me responsible and comfortable. It was a feeling akin to picking a fight with a big guy at a bar, while hoping that one of your friends would hold you back.

"Uh, okay," I stammered, still a little rocked from her unreserved support. "Well, then . . . I'm gonna do it. I'm gonna leave in May right after school."

"How long will you be gone for?"

"The summer. I'll get back in August."

"Oh, okay," she said brightly. "How's everything else going?"

"Uh . . . it's good. Yeah, school's fine and everything. Just wanted to let you know what I was doing with the money."

"And that's it?" she said, almost sounding a little disappointed that I didn't have more to tell her.

When the conversation ended and she had hung up the phone, I scratched a hole in the ice caked on the inside of my window. Looking out across the parking lot, I could only make out a small, circular image of the Hyalite Mountains off in the distance. Everything in my peripheral vision had been fogged over; there was only one thing left to focus on.

Fourteen

THE DOG SHOW

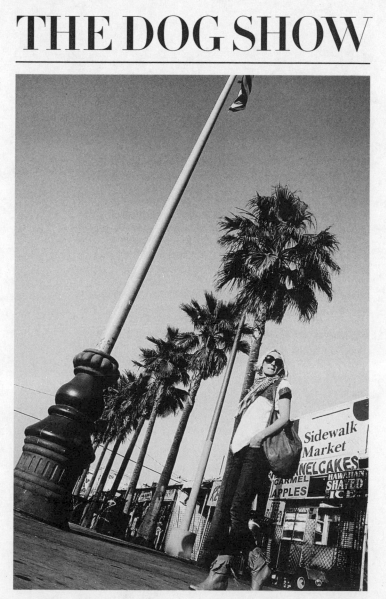

Los Angeles, United States

Venice Beach was like an attention convention. I'd never been to Los Angeles before, but I understood that it was a city more known for its clogged freeways than vibrant pedestrian life. I also knew that Los Angeles was a city that traded largely on celebrity and glamour; nowhere else did so many people make so much money simply from their appearance.

Before leaving Montana, I'd bought a small black journal that I planned to use as a logbook for my photos. On the first page, I had scrawled the few famous locations that I'd heard about on television: Hollywood Boulevard, Beverly Hills, and, finally, Venice Beach. Venice Beach was the last place I visited but by far the most exciting.

When I first began skating along the beach, I wanted to gawk at nearly everyone I passed, from the street ballers who played on the big, sun-bleached basketball courts to the art dealers peddling their own colorful paintings and sculptures. There were surfers, rollerbladers, skateboarders, and even the occasional unicyclist on the boardwalk. I began to think that I'd blend into the shuffle of unique and colorful people who populated the area.

A thin film of sand crunched beneath my wheels as I pumped the board for more speed. The granules flicked up into my face,

and I stuffed my camera into the small pack strapped to my chest. The finely ground powder covering the promenade was awful for my skateboard and camera gear. I cringed, sensing the grit working its way into the ball bearings. I'd only been able to bring along a few replacement parts, and it was discouraging to lose a set of bearings on my third day of shooting.

My gear—the shoe, the single backpack, the skateboard, the duct-taped gloves—were the same as on my trip to Europe, with one exception. Days before setting off from Helena, I tethered my camera to my watchband with high-test climbing line and a couple of buckles. It was like an extra insurance policy on the $3,000 camera I'd purchased a month earlier. If I was going to be skating through crowded areas and traffic with one hand, while holding this pricey piece of equipment in the other, I needed to attach it firmly to my body.

A stack of plane tickets shoved into my dirty backpack were to take me westward around the world, starting from Montana. I had only three months between junior exams and senior classes, so I set out just days after school ended. My first stop was Los Angeles, and I viewed it as a five-day training session on traveling and shooting. It was crowded, and certainly different from anywhere in Montana, but it was still more accessible than some of the places I planned to visit.

The idea was to keep moving as much as possible and to stay no longer than a week in any country. Ideally, I would have liked to travel more slowly and deliberately, but I needed to make sure that my investment was not made in vain. If I was operating under the concept that I would cause a double take wherever in the world I went, I needed to sample as many different cities and countries as possible. Since the photo series was as much a social

experiment as it was an art project, I had to figure out a set of controls to prove my point. In my logbook, I'd keep track of the total number of shots taken each day, as well as the location and country. At the front of the journal, scrawled in ink, were the rules that I'd created for myself:

> *Shoot every person that passes.*
> *Keep moving—never stop to frame your subjects.*
> *Never make eye contact—give them permission to stare by looking the other way.*
> *Don't try to attract people's attention.*

I wanted to prove my point as objectively as possible, which meant barring myself from selecting who to photograph and how to frame them. So, whenever I went out to shoot, much as I had done months ago in Vienna, I kept my eyes focused in the opposite direction of the camera that was discreetly held near my hip. That way, I was unable to really see whom I photographed or how they were composed in the viewfinder.

The next challenge was figuring out when to snap a shot. You know that little twinge on the back of your neck that occurs on the highway when you sense that a neighboring driver is looking at you? I centered my awareness on that twinge, and when I felt the tingle on my neck, I released the shutter.

Combining all of these elements was a test of my abilities to multitask, and the first day on the boardwalk was plagued with missed or blurry shots. I had to figure out how to push my skateboard with one hand and shoot with the other, while avoiding looking at my subjects and navigating through streets and crowds. There was no catch-all solution; it was about let-

ting that little tingle in my neck talk to my right hand and tell it where to aim and when to click, while at the same time trying not to fall off my skateboard.

I became so focused on the process that by the second day, I began to forget that the people I was shooting were human. In the midst of my dreamed-up rules and techniques, I'd forgotten that at times I might have to interact with some of the folks on the street. So when I heard someone shout, "Hey, bro! Bro!" I thought he was calling for someone else on the boardwalk.

"You! The short bro on the skateboard!" the man behind me drawled again. The voice was nearer this time, almost right behind me, and I jumped. I'd become used to hearing snippets of conversation or the occasional surprised gasp, which always faded quickly as I passed, but so far I hadn't been singled out.

I turned and saw a Pomeranian racing right beside my board. The tiny dog was less than a foot away, and I swerved to keep from running it over. It wore a pink leather harness connected to a five-foot leash that was wrapped around the hand of the man who had been yelling at me. A stocky guy in a threadbare tank top and multicolored shorts, his thick, tanned arms flailed for balance as he rode his board.

"What's up? What are you doing here?"

"Skating and taking photos," I said, keeping my eyes on the Pomeranian as it struggled to keep ahead of our speeding boards.

"Yeah, yeah, but what's your show, man? What's your gimmick?"

"I don't really have one," I responded, unsure how my presence could constitute a gimmick.

"C'mon, bro, there's gotta be a reason or a story to ya. No one

does what you're doing just for fun," he shot back, almost challengingly. There was an edge of competitiveness in his voice, as if I were a performance that he needed to upstage.

"Check this out," he said loudly, more to the people on the side of the boardwalk who ogled us as we passed. With a snap of the leash, he yanked the running dog off the ground. He lifted the Pomeranian so high that I had to look up as he caught it in his arms. "Check it *oooout,*" he repeated as he placed the dog on his upturned palm, as if he were delivering a pizza. We were both still skating, and I imagined the nervous hum of the dog's heart as it precariously balanced high above the rolling concrete.

"Dude, do you have a MySpace account? Like a website or something?" he asked.

I was growing tired of his enthusiasm and was concerned for the dog. It seemed as if the poor Pomeranian was the one taking all of the actual risk in this spectacle, and I gasped when he let his arm drop and the dog began a perilous fall toward the concrete.

"Don't worry, bro. I totally got it," he said, trying to alleviate my fears while he held the leash up high, dangling the dog over the ground like a yo-yo as its legs kicked furiously in anticipation of connecting with the moving ground.

"He does this all the time," he said, waiting for the dog's legs to gain enough speed before plopping it back to the concrete. "So what about your MySpace?"

"Oh, I don't have one."

"No worries, no worries," he said, pushing his board faster to get out in front of mine. Just before he veered off down a side street, he shouted the name of a website over his shoulder.

"Remember it, bro!" he yelled, already vanishing around the corner.

I'd forgotten the address before I made it back to my hostel in West Hollywood. The whole way, I kept thinking about the encounter, and how many dogs the man must have gone through to perfect his act. It was certainly a spectacle, and I didn't doubt that he'd attracted a good deal of attention over the years, but something about the brief conversation bugged me.

It was the question "What's your gimmick?" that got under my skin. He'd asked it with a demeanor that seemed as if we were colleagues working in the same profession and competing for the same audience. The way he treated his dog, dressed, and even tried to *network* bothered me.

But as I pored over some of the photos I'd taken earlier in the day, I wondered if we really were that different. He was gratified by the same sort of attention that I was getting, and while I didn't go out of my way to attract it, I was acutely aware of my effect on passersby. And, of course, the picture-taking concept was a bit gimmicky, as it derived from people's knee-jerk reactions to seeing someone very different cruise past their feet.

Maybe the answer lay within what he said shortly after: "C'mon, bro, there's gotta be a reason or a story to ya. No one does what you're doing just for fun."

I thought about that comment before going to bed, and what he must have imagined my "story" was. I knew he had one. Everyone did. Either I was a victim of a car accident or a war veteran. Shark attacks, thalidomide, or Chernobyl: the list of stories about how I could've come to be was long and almost always tragic.

I understood why people stared at me. I looked different. I should've probably been in a wheelchair. It would have looked

more socially acceptable than rolling across the ground on a dirty skateboard. But it had never been my job to be socially acceptable, and I had chosen my skateboard as a simpler and easier way of getting around. I'd made the choice to switch for my own reasons, but I never could've guessed the impact that it would have on others.

Could he not afford a wheelchair?
Is he homeless?
Does he need some money?

I could understand why those questions were asked. But still, it was exhausting trying to constantly justify my existence to others. It made me feel like an alien who needed to provide an explanation for how I arrived. Every question or assumption people made pushed me a little further from feeling human, and more like an act in the circus—something to stare at and wonder about.

Despite all of the hurt and alienation the skateboard had caused me, I couldn't give it up. It had also become part of who I was. *I* had chosen to ride the skateboard, and no one—no matter how much they stared or gawked or questioned—was going to get me to give it up, just to look normal. That board served as a representation for who I was and where I had come from: a world based on adaptation and practicality over aesthetics. It was a world I clung to, and without it, I wouldn't have managed to do so many of the things that seemed odd or even impossible to an outsider.

I was twenty-one and starting out on my second trip abroad;

I had carte blanche to skateboard in any airport or city without fear of reprisal; and I had an ambitious photo project that I'd never seen done before. It didn't seem like a bad set of circumstances, and as I fell asleep, I was reminded that those things had come *because* of my skateboard and the fact that I had no legs.

Fifteen

TOKYO STORY

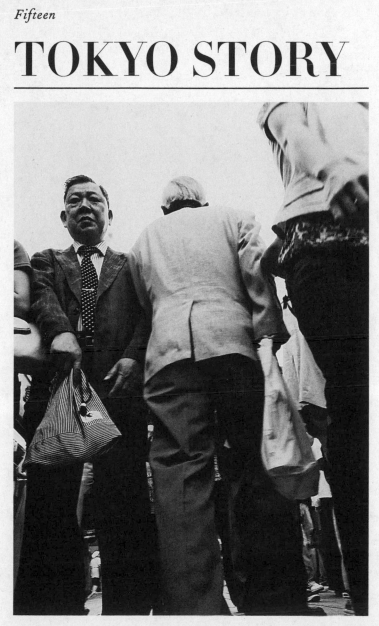

Tokyo, Japan

The palms of my hands were sticky after walking through the lobby of my capsule hotel in Tokyo. Every morning, a heavyset man would walk around the corridors of the hotel, showering the carpet in an antibacterial spray that smelled like lilacs pickled in gasoline. The smell clung to you, and even after a day in the city, I would occasionally catch it wafting up from my T-shirt. I desperately needed to get the smell off and was on a hunt for the spa room.

A capsule hotel is not a bad place to stay as long as you are willing to pack yourself into a coffin-sized fiberglass tube for the night. I tried to pretend that I was some sort of gaijin businessman, but with just a couple of ratty T-shirts and a week's worth of stubble, I don't think I convinced anyone. On top of everything else, I was the only person in the hotel younger than thirty, and the only one traveling by skateboard. Several of the businessmen gasped and gave a jump of fright when they saw me gliding by.

I certainly felt out of place and almost intrusive, but I tried to hide it under a stoic, blank-faced veneer. It was only when I crossed the threshold into the spa room that it dawned on me: *This is a public shower.* Steam filled my lungs as I took a deep breath.

Well, here we go.

I threw the towel over my shoulder and strode into the sweltering locker room. Stripping down, I stuffed my T-shirt and underwear into one of the thin cubicles. A locker room is one of the few spaces in which your eyes are always supposed to focus downward, so I kept my eyes toward the floor, examining the green grout between the tiles.

When I lifted my head, I was confronted with a cornucopia of male genitalia. It wasn't the sort of view that I had expected, but there it was. I drew my head back further and was met by a half-dozen middle-aged businessmen staring down at me. Their jaws had gone bipolar, either clenched in concern and sympathy or simply slack. Every guy rule about where to keep your gaze had gone out the window, and there was nowhere to hide. If only the lockers nearby had been slightly wider, I would have squeezed into one, pickling myself in my own nervous sweat.

But in that moment, I also recalled a distinct memory, one that had propelled me to come to Japan in the first place.

I was ten years old, and our family was on one of our few vacations in another state, at Disney World in Florida. On this particular day, we were visiting the Epcot World Showcase, a group of pavilions, each of which represents a different country, re-creating national monuments, points of interest, and architecture.

My family and I were in the Mexico pavilion when a Japanese guy in his late twenties suddenly started snapping photos of me. Mom and Dad saw him as well, but we had become used to ignoring the occasional person who wanted to do more than sneak an extra glance my way. I pushed my wheelchair a little

bit faster. It wasn't a big deal until he began edging closer to us, calling his friends over as he shot.

"Let's go," Mom said, and we all began heading briskly toward the exit. As we did, the young man stepped in front of us and continued taking pictures of me as he walked backward. Five more people came over—friends or family—chattering excitedly as they prepped their cameras to join in on our forced photo shoot. Soon they all stood before us, fanning out next to each other so that everyone could have a clear angle. Mom barked "EXCUSE US!" from behind me, but it was no good. We were blocked by their semicircle.

To our left in the distance towered the main attraction for Mexico, a re-creation of Quetzalcoatl. Up ahead were mini re-creations of Norway and China. The entire world had been manufactured here for people to feast their eyes on, but somehow I was more interesting to this group.

I wish the comedy of the moment had hit us, instead of the frustration, but at that age, it was hard to see the humor in the situation. I went silent and dropped my head.

I don't know if it was my slumping shoulders or my sisters yelling in the background, but Dad finally snapped. "All right, fuck it. Girls! Keep up!" he yelled.

Dad grabbed the handlebars on my wheelchair and steered it back and forth like a man threatening a mob. When the crowd backed up a bit, he gave the chair a hard push. The sea of amateur photographers jumped out of the way to avoid being caught under my tires as Dad shoved forward. Meagan and Shannon followed behind, with Mom bringing up the rear. Feeling persecuted, we fled the country.

Unfortunately, once Dad gets fired up, it's difficult to get him calmed down, and he pushed me straight through Norway before he slowed down enough for Mom and my sisters to catch up. By the time we'd stopped to regroup, we had run all the way to China. Turning up a shaded street that ran toward the shops and cafés, we tried to get off the main path and away from the crowds.

This is the part where one would expect emotion or hyperventilation, maybe even some tears, while we sat down and recovered. But aside from my dad's exclaiming, "That sucked!" we calmed down quickly. I was glad that they didn't dwell on the episode; I just wanted to get back to enjoying our rare week away from home.

"Who's hungry?" Mom asked, once we'd caught our breath.

Before the run-in with the paparazzi, we had all said we wanted to stay and see the Memorial Day fireworks. So that's what we did. After chowing back a greasy, stir-fried lunch, we wandered around the Chinese gift shop and picked out souvenirs to buy. I chose a little wooden figurine, and my sisters bought collapsible paper fans that Mom thought were overpriced. We killed a couple of hours wandering between the different pavilions, ignoring the glances and cameras until it was time for the fireworks display, which we managed to enjoy.

When I think back to that day, I realize that my "being normal" was only something that could be maintained insularly, within the circle of family and friends who knew me well. Unlike me, many people are able to hide their differences from the world. Whether it's not getting on the dance floor because you have wobbly knees or wearing turtlenecks to cover that scar on

your collarbone, you can exercise some form of control over how you are perceived by the outside world. But the fact that I don't have legs is pretty hard to hide. Even if I wore prosthetics, I still couldn't disguise the fact that I'm missing these limbs. Only when I'm inside my circle of family and friends is my disability so familiar that it's normal.

Yet I don't think of myself as "disabled." As I interpret the word, you are only disabled if you are incapable of overcoming the challenges presented in any given situation. I might be disabled when trying to haul a hundred pounds of concrete up a flight of stairs, but to my mind, I'm perfectly able-bodied when I am skateboarding around New York City. Being disabled is also a matter of choice. Anything that you try to hide from the world also imposes a limit on you. If you don't want to risk showing off your wobbly knees or clumsiness on the dance floor and decide to sit on the sidelines, then you are unable to dance. Thus, disabled.

Like it or not, my imperfection has always been obvious, and specifically to those six paunchy Japanese businessmen who were still looking at me in the locker room of the spa. There wasn't much that I could say or do, considering the language barrier and lack of threat posed by a group of short, naked men. So I decided to move on.

Hey, guys, I'm only here for a shower. Everybody needs to just chiiilll ooout.

SLOW
DANCING

Tokyo, Japan

During *my seventeen-hour* flight from Kuala Lumpur to Paris, I'd been running through the things I needed to do before seeing my girlfriend. Since Beth lived in New Zealand, I hadn't seen her in half a year, ever since I left Christchurch. My nervousness made even the most routine things seem difficult:

Take a shower.
Shave.
Brush teeth (and floss if you can find string).
Buy a bottle of wine.
Change into your one clean shirt.
And most important: Play. It. Cool.

But after checking into my small hostel in Montmartre the next morning, I was too nervous to focus on the list. Things kept getting mixed up in my head, and just as soon as I'd get ready to change into my one set of clean clothes, I'd realize I'd have to take a shower first. But then I'd also realize that I'd just get dirty again if I got the bottle of wine *after* showering.

I hadn't taken my shower yet, and "playing it cool" had already gone out the window and over the small balcony to the

street below. I knew that shaving was somewhere on the list, and I had just covered my face in a thick lather before realizing that I couldn't reach the mirror to see what I was doing. My nerves were already jangling, but the minor crisis of having my hands and face covered in thick foam sent my head into a tailspin.

Oh God, Beth could come in at any minute, and I'm going to look like such an idiot, I thought. There was one chair in the room, and I grabbed it by the front leg and dragged it across the uneven floorboards toward the tiny sink. The chair leg got coated with the slick foam from my hands, and I ticked "clean chair" onto my discombobulated mental list.

As I pulled the blade across my face, I reminded myself to be careful around my chin. After snapping my jaw skiing a year ago, the surgeon was forced to put a small metal plate on the left side of my cheek, which had caused me to lose all feeling in that part of my face. Not as big a deal as losing feeling in, say, your hands, but it did make shaving a delicate process.

If you see her for the first time in six months and have a bloody scab covering a third of your face, then you're really going to look like a jackass, I thought, guiding the razor slowly with both hands.

Beth and I had first met in July 2006, when I was on the exchange program in New Zealand. We had been running with the same group of Kiwi friends for months, and I'd talked to her a few times at different parties around Christchurch. I had wanted to ask her out for a while but had never really gotten up the confidence. I kept meaning to, but I always delayed with feeble excuses such as "Now's not the right time" and "Maybe I'll just get her phone number and ask her later."

Beth was a petite girl with a soft, friendly face that would crack itself almost in two to accommodate her smile. Her hair

coiled about her head in a tangled mess of curls. Before going out, she'd carelessly run her hands through it, giving her an even more chaotic appearance. She was funny, cute, and one of the most inviting people I'd ever seen.

That said, once you spoke with her, you quickly realized that her character did not at all correlate with her small size. She was a native New Zealander, having grown up on a farm on the North Island, and was the eldest child and only girl. Her three brothers were all nice guys, but their presence no doubt contributed to her toughness. She didn't put up with whining and would actively call people out for being a "softie." She was—and still is—one of the most intimidating women I'd ever met.

Those qualities, while frightening, were precisely the reason I was so attracted to her, but it wasn't until we were both invited on a high-concept camping trip called "The Bush Ball" that I finally got the guts to ask her out. The basic premise for the event was to have forty or so hikers venture into the woods, carrying all the necessities for a night of partying. Upon arrival, the hikers would change out of their dirty clothes and into their finest attire. By six P.M., the campsite had transitioned into a slipshod formal affair. Everyone was in either suits or ball gowns, though long underwear could be seen peeking out from the bottoms of their fashionably wrinkled dresses and slacks.

Beth volunteered to bartend for the night, a position that traded the glamour of a mahogany bar and shot glasses for a picnic table and Dixie cups. And in a sneaky attempt to get close to her, I volunteered as well.

I'm not a confident guy when it comes to asking a girl out on a date, and while I'd had my eyes on Beth for a while, I was still in recon-gathering mode. Asking her friends if she was sin-

gle, making small talk, feigning charisma whenever the chance arose—the sort of stuff you do when you're trying to delay the inevitable moment of asking someone out.

My lack of confidence probably came from my earliest dating experiences, back when I was in middle school. I had three options when it came to participating in school dances: either on my hands, in my prosthetics, or in the wheelchair. I was too low on my hands but too slow in my prosthetics, so the wheelchair was the best bet.

But "best bet" for me was really the lesser of evils when it came to a school dance. The weeks leading up to the event were always the worst. Fretting about who to ask and assessing a potential girl's openness to a date: there were many important considerations that went into my choice.

Once I decided on a prospective date, it was time to draft The Note: a "yes" box, a "no" box, and a simple question written on notebook paper. Often the note came back with "maybe" scribbled outside the two options given. That sonofabitch "maybe"— it always had a mocking appearance for taking artistic license with a very specific question, as well as acting as a euphemism for "ain't happenin'."

But when the occasional "yes" did land, my next worry was, How will I dance in a wheelchair? I realized that my mouth had asked for something that my feet couldn't deliver. Should I just roll around real quickly? Should I allow myself to be pushed by my partner?

Dancing is a pretty gorgeous expression of what a body can do, not in terms of great feats, but of seeing people create spectacles of themselves, whether professional dancers onstage or your drunk uncle at a reunion. Dancing shows not only that you

are in tune with your surroundings (the music, your partner, the dance floor), but that all of your parts are working well enough to move in concert. To dance is to be youthful and frivolous and alive, and a whole host of other adjectives that all boil down to one thing: the dancer has no other purpose other than to show off his or her body and what it can do.

That said, I've never felt more legless and incomplete than when watching someone dance. It makes me feel old, sitting on the sidelines of a party or standing in a school gymnasium, looking on as the others cavort, while keeping company with parents and chaperones.

And as a guy, you always want that slow dance. You wait around for it, and the second that you hear the first few overproduced piano notes or the croon of some husky-voiced English troubadour, you either grab your date or try to scoop up the nearest warm body. Instead of an overt display of physical prowess, slow dancing is a private conversation; something shared closely between two people, whether they're thirteen or fifty-seven.

The first girl I recall slow dancing with was in seventh grade. I remember swaying back and forth, watching other kids either hugged-in close or at least looking each other in the eye. Instead, my arms were stretched out above the empty footrest on the wheelchair while I peered up at my date like a little kid looking at a babysitter. And when our swaying did move us a bit on the dance floor, my chair's front wheels rolled in a stuttering and manic fashion, not unlike those of a shopping cart.

Beneath the pink dress, I could feel her hips moving back and forth with a creaking, seasick motion. With her hands on my shoulders, we squared up like that for the three minutes it

took for the song to play out. When we parted, I looked over to see where my hands had been. In their place were small, dark patches of sweat where I'd held her.

I don't know how much of my embarrassment or frustration was shared by other school-dance dates over the years, but most of the discomfort was probably in my head. I'd never really made peace with the fact that occasionally I had to use a wheelchair, and while I could shove that uneasiness into the back of my brain most of the time, dancing always brought it out.

The physical act of dancing became more comfortable as I got older, but even as I left the high school proms and formals behind and moved to college, I cringed inside anytime I ended up in a social setting that involved shimmying around a dance floor.

So there were several motives that put me at the picnic table bar at the Bush Ball. It allowed me to avoid dancing, stay close to Beth, and shout my attempts at charming lines over the loud din of the music. As we flirted throughout the night, I began to realize that there might be a faint glimmer of hope.

With an open bar and a gaggle of parched university students, we were mobbed throughout the night. Cutting lemons for the watery tequila shots people were throwing back, I tried to keep pace with pouring drinks, all the while trying to flirt with Beth.

Multitasking is not my strong suit, and by the eighth or ninth lemon, one of the juggling balls dropped. As I cut through the fruit, I felt the knife bury its serrated edge into my thumb as the citrus juice soaked into the wound. Quickly sticking my hand into my suit jacket, I called for Mike, one of the club captains on the trip. Beth temporarily took over the lemon-cutting duties, while Mike and I examined the disappointingly sparse contents

of the first-aid kit. As Mike quickly shuffled through the tin box, it became apparent that we had run out of bandages.

But the wound was bleeding profusely, and we were forced to cobble together what we could to stop the leakage and get on with the festivities. Grabbing a condom, some rubbing alcohol, and a bit of packing tape, I quickly rolled the prophylactic over my thumb and wrapped it tightly with thin strips of tape. Once we'd dressed the wound, I had a shot of vodka to numb the pain and resumed my duties as barman.

Maybe it was due to a mix of booze courage and blood loss, but as the condom began to inflate with blood, so did my confidence about asking Beth out. Around midnight, I popped the question during a lull in the music. She looked at me for a few moments before answering. I felt almost as if I were at a job interview.

"Uh, yeah. Sure. That'd be fun."

Success! I began to relax as the small victory of the moment set in.

As the night wore on, the partyers began to get cold, and one by one, they teetered off to their tents. Beth took a break from the bar to join some remaining friends on the impromptu dance floor. With music still pumping from the speakers some poor soul had packed all the way into the woods, my nerves began to retie the knot that had unraveled only an hour ago.

I didn't have my wheelchair or anything that I could use to pick myself off the ground. As I watched the remaining hikers shaking their body parts for nothing but the fun of it, it all came back. I felt so incomplete as I sat at the edge of the booze-soaked picnic table. I looked down at the trampled dirt floor and wondered what dancing feet would have looked like had they been mine.

But just as quickly as it began, I was physically yanked out of my mood by Steve, the other club captain. Sloppy drunk and beaming with extra energy, he scooped me up close to his chest and began swaying around the room while holding my arm out as if we were ballroom dancing.

"Christ, you're heavy!" he slurred above the music.

I laughed as we tumbled around, realizing that the only person who was uncomfortable around me on that dance floor was me. Maybe all of this panic and embarrassment was due more to the stress of dating than being legless. And you know what? It wasn't quite what I was hoping for, but nevertheless, I finally got my slow dance at the end of the night.

Beth and I went out to dinner the next week, and then the week after that, and before the month was over, we'd slid into a relationship. She was the first girl that I went head over tailbone for. She was cute and funny and like no one I'd ever met before. She had ladylike principles—she didn't smoke or drink, or even stay overnight that often—but she enforced them with a very unladylike zeal. One night, she punched me in the face after I made an off-color joke.

"Not funny," she said, drawing another line.

She had a good arm on her, and while my cheek stung, I thought, *That's so hot.*

She didn't care about the wheelchair, or the fact that sometimes I'd tackle her to bring her down to my level and steal a kiss. She told me that the only time being around me was hard was when I made a big deal out of the no-legs thing.

"Look, if you're going to sit there and be shitty, I'll just leave you," she'd say with a mix of flippancy and seriousness.

As my last weeks in New Zealand wound down, we spent as

much time together as we could, but there was no delaying the inevitable. It was like looking at a Band-Aid that you knew had to come off.

This is going to hurt. I know it's going to hurt. There's nothing I can do to prevent it. Here it comes . . . OOOOWWW!

At the airport on the day of my departure, Beth was the last one I turned to in the half-circle of friends that had come to see me off. She dropped to her knees before me, crying. For the first time since I'd met her, she was openly not being the tough Kiwi gal that I'd come to like so much. We hugged, and she nodded into my shoulder while we both muttered, "It'll be all right." It was a breakup born not of disagreement or anger, but of geography. The comforts we tried to squeak out were a poor cover for the underlying feeling that we'd never see each other again.

We stayed in touch, though. I went through Europe and began shooting my photos. She moved to Sweden for the year as part of her own exchange program, and we both talked about our plans for the coming summer. It wasn't until February, when I'd received my X Games money, that I started to think that I might be able to see her again. When I began planning my schedule for the summer, I asked her if she wanted to travel together.

The e-mails that we sent back and forth over the following months were enthusiastic but unsure. Of the two of us, she was the realist when it came to talking about joining up again in Europe. Once I'd booked a room for us in a hostel in Paris, she began to voice her concerns.

"I don't know what you're thinking, but I'm not sure if there's anything left between us. We might get back together, or we might be traveling only as friends. I can't make any guarantees."

"Until when?" I asked, the word "friend" striking a particularly worrisome note in my ear.

"Until I see you. Who knows, I could feel a million different ways," she said, drawing another one of her staunch lines.

Still, as I skated through Venice Beach, I'd blindly hoped. Then I began to fret when I was plowing through Kuala Lumpur. By the afternoon of her arrival in Paris, I was in a panic. She had said that her bus from Sweden was coming in at five that afternoon, and I kept checking my busted-up wristwatch, watching the hours tick by interminably.

At three forty-four, I'd finally finished shaving. I rushed down the narrow spiraling stairs of the little hostel to the community shower. I washed quickly, scrubbing my hands to remove the stench that my sweat-soaked gloves had rubbed into my skin.

At four o'clock, I was back in my room brushing my teeth, cursing myself for forgetting to pick up floss. Rather than spend time going out to find some, I picked up an old airplane ticket and ran the edge of it between each tooth. At four ten, I was out the door and skating down the block to a little corner market I'd seen earlier that day. I picked the bottle of red wine that had the Frenchiest-looking label and grabbed a baguette before heading back to the hostel. Carrying the bottle and loaf of bread up to the third floor was a mission, and I left a trail of bread crumbs behind me as I hauled it to my room.

By four thirty, I was lying flat-back on my thin double mattress, staring up at the ceiling. I'd put on my last clean articles of clothing—a red T-shirt and a pair of jeans—and waited.

And I waited, telling myself to be patient.

Ages passed before I looked down at my watch again. Four thirty-eight.

If I just try to sleep, this'll go by faster.

So I closed my eyes and rolled over on my side. My mouth tasted as if it were filled with old nails, and I ground my teeth as I tried not to think about how things would go when or if she arrived. I was exhausted from jet lag, and despite the nerves, I managed to pass out.

When I opened my eyes, dusk had fallen, and the room was still empty. I hadn't been awakened by a knock, and I didn't see any new baggage on the floor. I waited as long as I could, trying to deny the fact that it had begun to get dark out, before flicking on the fluorescent light that bathed the room in a sickly wash of green.

I'd had all these romanticized notions of what it would be like when she arrived. I would be clean and shaven, and, ultimately, one of the suavest guys around for having made it all the way to Paris to see her. We would open the wine and share the baguette in the tiny room before I wooed her to bed.

Instead, I sat there eating the bread and watching crumbs fall to the floor. After a few starchy bites, I popped the bottle of wine and took a swig. It was bitter, but I had a few more sips and tried to consider what might happen.

Maybe she's not coming, I thought as I lay on my bed, looking up at the high ceiling. My watch read ten. I took it off with a loud rip of the Velcro band.

Maybe I came on too strong about wanting to get back together.

Maybe I sent too many e-mails.

Maybe she found a new guy and thought this would be too complicated.

The bottle of wine was half gone by the time I'd run through most of the reasons why she wouldn't show up. I knew I needed

to get out of the hostel and get some fresh air instead of just sitting inside and stewing. So I corked the bottle, grabbed my board, and bolted.

I didn't have a plan as I rolled outside, but all of the pent-up panic released itself once I began pushing through the still-busy streets of Paris. I didn't know where I was going; I was just trying to outskate my own building neurosis.

I rode hard down a long, gradual hill that led to the Seine and got going fast enough to pass the cars that weaved through the crowded streets. By the time I made it to the wide, lazy river that cut its swath through the city, most of my worry was gone. A couple of close calls with merging traffic had momentarily refocused my nerves from Beth to the much more tangible fear of getting squashed under a car.

I was drenched in sweat by the time I made it back up the hill to my hostel. The push had taken it out of me, and the ache in my head acted as a fond reminder that wine was probably the worst sports drink in the world. When I opened the heavy wooden door and looked into the lobby, there she was, standing there, talking to a woman behind the front desk. She had a small backpack with her—smaller than mine, even. Her hair had grown past her shoulders and was even more psychotic than I remembered. And she was still gorgeous. In that moment, all of the problems I'd been dreaming up that day, all of the lists I'd made, and all of the concerns over what would happen hit me like a ton of bricks.

Oh shit.
My breath smells like wine.

The bed is covered in bread crumbs.
My one nice shirt is drenched in sweat.

"Hey!" I said, standing in the entrance and still holding the door.

She turned and looked at me.

"Oh, hey. I missed my bus," she said, as if we'd seen each other only a few hours ago.

Of all the excuses I'd expected, I hadn't thought of the most obvious. I stood there, stunned.

There was a second, maybe more, of silence as we evaluated each other from across the room before she screamed and rushed at me. She was in a full sprint by the time her head connected with my chest, and we both went tumbling backward out into the street.

"Jesus, you smell *awful*," she said as she buried her face in my shoulder.

We held each other for a while before she whispered, "Hey."

It wasn't the word but the tone that said nothing had changed.

SARAJEVO ROSES

Paris, France

Two *nights before* leaving Montana, I'd ordered a set of new milk-white wheels from my longtime skate sponsor, Sector 9. When they came out of the box, the wheels still smelled of the thick, polyurethane composite that left the edges so soft as to be almost pliable. They were nearly translucent, and I mounted them onto my board carefully, giving each a test-spin with my hand before taking them outside.

I remembered marveling at how slick and classy they looked as they rumbled along the segmented sidewalk outside my parents' home. As each wheel thunked lightly over the small cracks in the concrete, I felt a sense of security and readiness for the travel ahead. That sensation of feeling well equipped must have been similar to the first time someone takes out a new pair of hiking shoes before a trip.

But as Beth and I arrived in Sarajevo on my tenth week of travel, the wheels had turned a dirty brown. On one, there was a thick splotch of gum that had gone hard and black. On another were tiny cuts from a broken beer bottle I'd run over back in Malaysia. The back wheels had even started to break apart, the once-pliable edges snapping off in tiny chunks whenever I turned.

But it wasn't just the wheels that had started to break down.

My board had been abused, the grip tape wearing through in spots to the wood beneath. I had even worked my way down to the last of my gloves; every pair now sported holes in the fingers. In an effort to conserve the little handwear I had left, I'd begun to skate gloveless, letting dirt and the occasional scrape accumulate on my nails and knuckles.

Not that I minded the raggedy look. Instead, I had become rather proud of it. I felt like a war-weary journalist, prowling the streets and snapping photos by feel.

We'd already spent a few days in Sarajevo and had found a room on one of the high hills that fenced in the central city. The path to town was steep, and what little fabric and tape were left on my gloves burned off as I tried to control my board down the precipitous descent to the edge of what was called the Turkish quarter of the city.

The Turkish quarter was filled with hostels and was the departure point for a number of tourists looking to explore Sarajevo. Groups of college-aged kids walked through the tightly clustered neighborhood of beige buildings that peddled cheap gifts and memorabilia from the war. Most of them wore ratty T-shirts and carried large bags as they looked around, like refugees, for a place to sleep. Hundreds of them swarmed throughout the narrow walkways. They stood next to a building, photographing the strafe marks that punctured the walls, or perused the war memorabilia shops that were scattered throughout the area.

I'd seen the images of Sarajevo during the Balkan wars in magazines and on television. You could buy some of those magazines as collector's items on the streets, the old ink stiffening each page like stale bread. Beth and I spent our first day perusing the shops and magazine stalls, looking for souvenirs to send

back to our respective families. It was surreal, looking through boxes of AK-47 shells turned into key rings for purchase.

Beth grew tired of sweating it out on the streets by the second day, so she took to finding a café during the heat of the day and reading, while I continued to shoot. We'd been traveling together for over a month, spending almost every waking moment together. And while our relationship had quickly rekindled itself, it was still nice to have a few hours alone to work on my photographs.

During those hours, the sun baked the city and left the few pedestrians bathed in sweat. The nicer shops and restaurants doused the rough-hewn tiles in front of their entrances with water. A half dozen hoses extended from darkened doorways and poured water out onto the scorched sidewalk. The water cooled the ground slightly, washing the morning's desiccated dust into the cracks between each tile, but not enough to relieve the heat. Instead, the water festered and splashed up into my face each time my wheels sunk into the deep fissures between tiles.

On this particular afternoon, I'd run out of memory on my camera and needed to find a place to sit and delete some pictures. I skated into a small courtyard off the main street. Pulling the camera out, I threw my head back against the wall and idly surveyed the courtyard.

It was almost empty, save for myself and one other man who stood in the opposite corner, carefully balanced on a pair of old wooden crutches. His left leg stopped at the thigh, and the canvas fabric was folded underneath the stump of what was once a healthy limb. His left arm ended just past the elbow, which he tucked underneath the handle of one of his crutches.

I'd seen him a few times, usually standing several blocks

away from the bombed-out city hall building. He begged in the late afternoons, when the sun was starting to set behind the mountains and sent the city into bearable temperatures.

I was trying to figure out how he could get around on crutches without being able to grip the handles, when he looked over and nodded at me. It wasn't an encouraging or enthusiastic nod, and I would've missed it if we hadn't made eye contact. It was the nod one coworker gives to another in the hallway, conveying a mutual respect born of knowing that you are both in the same mess together. I nodded back, emulating his grimace before bowing my head toward my camera.

Why did you nod? I asked, flipping idly through the photos on the full card. It was a question that I didn't know the answer to, and up until this moment I had made a point not to ask. It was the same as all of those weak smiles or "thank you's" when people had given me money. I'd never explained myself; instead, I'd let the people around me create an idea of who I was or what I needed. I'd been a beggar in Ukraine. I'd been a shark attack victim in New Zealand. I'd been a car accident victim in Malaysia.

More memories came as I sat there, my back slumping into the wall. I'd been asked by a woman in New Zealand if I was a thalidomide baby. I'd been asked by a guy in Helena if I still wore my dog tags from Iraq. Sometimes I'd given the "born without 'em" response, and sometimes I hadn't. Sometimes, I'd been too lazy to explain myself. A lot of the times I'd been too lazy to explain myself. I'd just grown accustomed to looking the other way and letting people think what they wanted to about what "happened" to me.

The faces in almost every photograph I'd taken showed a

mixture of pity, sympathy, and kindness, sometimes even pain. Especially here, in Sarajevo, I'd seen more of it than normal. The evidence was everywhere. Buildings still bore strafe marks from bullets fired over a decade ago. There were small cemeteries, some of them sized only a couple of square yards, dotting our neighborhood on the hillside. The most noticeable, though, were called the Sarajevo Roses.

Each rose was a monument made of blood-red resin that filled the holes that Serb mortar rounds had created in the cement footpaths around the city. Each rose had once been a real mortar hole. Each rose had also been the site of at least one person's death or wounding. I'd rolled over dozens of them, without ever for a second thinking that maybe, just maybe, people were connecting those roses—those mortar rounds and bombings—to me.

And why shouldn't they have? Certainly here, my being blown in half by a mortar round was a more plausible explanation than being born without legs. I was roughly the same age as the man across from me, and we both had the same burly physique. Hell, we could have gone to the same school just before the war erupted.

The clean, smooth stump of his arm made me feel queasy thinking about how he lost those limbs, and I snuck a few quick looks over at him as I deleted photos from my camera.

Did he lose them together or in separate instances?
Was it a mortar round?
A grenade?
Could he have lost them to an infection?

I didn't want to wonder about him, but I couldn't help myself. A guy like that, standing in Sarajevo: he *had* to have a story. It was difficult to imagine one that excluded violence.

It had to have been tough for him, trying to recover from such a huge loss, maybe even harder trying to learn how to get around once his wounds had healed.

I felt so bad for the man. A frown of pity creased my mouth as I deleted the photos faster and faster.

Those crutches couldn't have come naturally to him. It wouldn't have been easy, especially dealing with all of the startled reactions and hushed voices that go along with looking . . . incomplete.

And then I felt sick. Really, properly sick. I put the camera away. I didn't want to shoot anymore.

Do I bring up these feelings in others every time I step out the door? Do I darken their day, reminding them of a time they'd wished to forget?

I kept my eyes down as I skated by the man and out of the courtyard. The only piece of him that I saw on my way out was the rubber nubs affixed to the bottom of his crutches. They were dirty brown and chipped from use in places, just like my wheels. I pushed faster, my hands gaining traction as I exited onto the street.

I knew that I couldn't explain myself to everyone. It was too easy to recall all of my failed attempts in Vienna, or Ukraine, or Croatia. People were going to create their own stories about who I was, regardless of what I said or how I felt. These stories varied wildly, except for one common element: in every narrative, I was the victim of a tragedy.

I'd created this project, this summer job that was predicated on being a legless guy. But I hadn't realized that it wasn't only

about what people were doing to me, but what my presence was doing to them in return. I'd taken these handouts and pitying frowns and selfishly manipulated them into my own cathartic art project.

But it wasn't as if I could simply stop being a legless guy. I wanted to crawl out of my own skin. Disappear. Do anything to just stop existing, because in that moment, I felt that my existence was causing these reactions. But beyond crawling into a very dark hole, I couldn't stop or prevent the looks I received as I skated through the city.

I had a little under a mile to go before getting back to the small café where I'd last seen Beth. I wanted to find her as fast as possible and just . . . sit. Sit with someone who knew that I wasn't a beggar or veteran or victim.

I counted three Sarajevo Roses in that single mile between her and me. The water that was still washing out onto the street had cleared the dust from the Roses, and they stood out, sanguine and bright, as I pushed myself over them.

The resin that filled these holes was smooth, and my wheels temporarily hushed themselves as they rolled over each memorial, like a moment of reverence before returning to the growling concrete. I kept my head down, avoiding people's gazes and focusing on the occasional bright flash of a blood-red rose.

I don't remember much of that afternoon except for what was below me. I remember watching the white rock tiles of the Turkish quarter turn to black asphalt as I skated farther into the city. I remember how hot the street was beyond the shops, half-melted tar sticking to my bare hands. I remember trying to rub the black muck onto my skateboard as I bounced over the rough alleyway pavement toward the café. I remember the book Beth had on the

table—*The Sarajevo Survival Guide*. I remember looking down at her lap and wondering if she could feel the tears that soaked into her summer dress. And I remember my throat hurting as I tried to explain myself.

"What's wrong?" she asked softly, her hand on my back.

"I don't think I can shoot this anymore."

"Why not?"

"I think I'm hurting people."

"How?"

"People think I'm a beggar or someone who was hurt here."

"Well, yeah. Maybe some people. But that doesn't make you any more of a beggar than you were a month ago. You and I know who you are, so don't let it get to you."

"Yeah, but I'm using them for the photos."

"So? It's not as if their entire day is ruined or anything. You're getting too wrapped up in everything. If you stop shooting and just quit, you're going to hate yourself forever."

When I looked up at her, she smiled.

"Yeah. Maybe you're right."

"I know I'm right," she said pertly. "Plus, if you keep moping, I'll drop you. So go get a beer and toughen up."

I didn't want to, but I choked out a laugh.

"All right," I said, hopping off the chair and walking into the café.

I drained three beers before setting out again to shoot, and by the time I rolled back out into public, I was comfortably numb. I kept shooting the next day, hitting the shutter almost mechanically as I drifted by people. I didn't feel like a photojournalist anymore; instead, I tried to cling to the notion that only later would I appreciate what I did in Sarajevo.

When Beth ducked into a café or took a break from the heat, I'd go off and quickly down a few drinks. It wasn't a healthy or smart solution, but the alcohol worked as a temporary patch to quiet the shame that caught in my chest every time I heard that reverential hush as a group of people passed me.

Our fourth night in Sarajevo was our last, and as the sidewalks cooled in the darkness outside, we quietly stuffed clothes into our dusty, beaten backpacks.

Beth's bag had begun to tear at the seams, and I smeared a few rations of duct tape onto the ripped stitching in a feeble attempt to keep it from spewing its contents.

"Beth, I don't know how much longer this is going to hold. The tear seems to be getting worse."

She shrugged. "Oh well. I only paid about ten dollars for it, and besides, it only has to last me another week or so."

"Yeah," I said, not wanting to think about our inevitable split. "Hey, do you want to see some of the photos?"

She giggled as she found a seat on the edge of the bed. "I snuck a look while you were in the shower. They're really good. You just need to stop putting yourself through all that stress to get them."

"It's okay, we're leaving. I think that'll make things easier again," I said, trying my best to believe the words coming out of my mouth.

PARTING

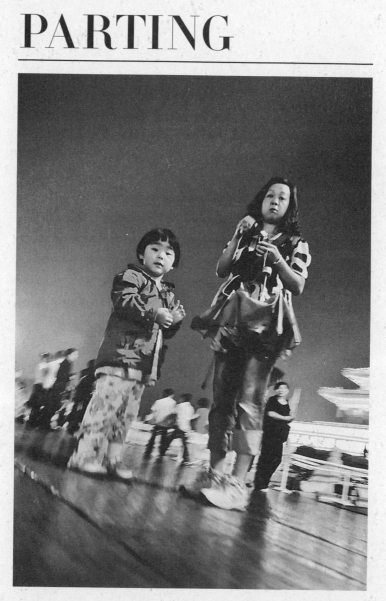

Beijing, China

B eth, *just give* me one more minute," I yelled from the ground.

In my camera's viewfinder, I could see four, meter-long dashes of gray rock that erupted from the beige wall and towered over my lens. The sidewalk even looked the same, disappearing into the distance as I tried to replicate the perspective of the first shot I'd ever taken from my hip.

"Kevin! We have to leave now!" Beth hissed. "We've got to get to the bus station."

"I just need to get the angle right," I said, lying on my back in the middle of the sidewalk as a group of tourists streamed around us.

After leaving Sarajevo, Beth and I had cut through Serbia, Romania, and Hungary, before finally landing in Vienna on our last day together. Beth had to get back to Sweden to continue her studies at Lund University, while I had two more countries to visit before returning to the U.S. Our respective buses were due to leave that afternoon within a few hours of each other.

We'd spent most of that last morning lying in bed, trying to avoid looking at the already-packed backpacks that were huddled in the corner of our room. Our hostel was clustered among several high-rises that shaded our window from the morning

sun. The formless gray light was welcome, though, and let us delude ourselves into thinking that the clock would remain stopped until we exited that room.

By the time we'd stashed our packs behind the front desk and stepped out of the hostel, the sun had already begun to creep above the apartments. We only had a few hours left, so we set out to try to see something of the city before rushing back to the bus station.

The hostel we'd found was just a few blocks from the one that I'd stayed in nine months earlier, and after a while we found ourselves walking down Mariahilferstrasse. We passed the same bratwurst cart where the man had given me the sausage during my first night in Vienna, and I pointed out the boarded-up stall to Beth as we headed toward the center of the city.

When we arrived at the expansive courtyards of the Hofburg palace, the old Christmas markets were gone. In their place, sprawling, manicured lawns were already filling with picnickers and tourists. We didn't have time to explore the city, so we plopped down on the grass and idly watched as streams of people passed us on the nearby sidewalk.

Weeks ago, we'd had a talk about what would happen when we had to part ways. Neither of us was comfortable with having to deal with the stress of "relationship talk," nor did we want to ruin what had come to be an amazing trip. One night we succumbed, though, and treated ourselves to a dimly lit restaurant, dinner, and a few glasses of wine. It wasn't until the plates had been cleared that we finally broached the subject. I hadn't really dealt with a talk like this before and dove into it clumsily, without preamble.

"So, August 3 I leave for England. What're we gonna do?" I said, twining my fingers together.

Even through the wine, she remained a realist. "I think . . . we'll just have to break up when you go home," she said matter-of-factly.

The decision made sense, but it still stung. I didn't want to let it go, though.

"Well, what about e-mail or phone? We could keep this going if we just—"

"I don't see how that could work and be healthy. Besides, neither of us has any money, so when would we see each other again?"

Damn it. It was frustrating to know that she was right.

"So that's it then. That's the date?"

"Yup. Guess so. It's not like I enjoy this any more than you do, but we're still so young . . . " she trailed off.

"Well, then let's just try to have fun and not talk about it again. Okay?"

"Okay."

We kissed and sealed the decision.

We didn't talk about splitting up for the rest of the trip, and even as we lay down in the grass, we avoided mentioning what was to come in the next few hours. It was tough, though, just lying there and watching the time pass. I felt like we needed to be doing something, like we were wasting time by being stationary. Since that morning, my head had been filled with fractions. Every hour that passed was a larger portion of the last bit of our time left together. It bothered me to know that I had such a sentimental streak, but I couldn't get the idea out of my head. To

curb my own sappiness, I tried not to think of the time. I stopped looking at my watch and eventually zipped it up into the front pouch of my camera bag.

She must have felt that time was wasting as well, as she was the first to get up.

"Do you want to walk around real quick?"

"Where do you want to go?"

She shrugged, which was enough for me. I sat up and put my camera bag back on before following her through the expansive courtyard. Neither of us had a map of the area, and we quickly became lost in the tightly winding streets that wormed their way behind the palace. We knew that time was getting short, and we had to start heading back toward the bus station, but we kept getting turned around, looping back on avenues we'd been down only minutes before.

Beth finally spoke up as we rounded another corner.

"Kev, we need to figure this out right now. Go ask for directions."

"No, no. We don't need directions. Besides, most of the people probably speak Austrian, or at least something other than English."

"Everyone speaks English here, you dork. Just go ask someone."

I looked up at her, frustrated, as we walked. It took a second to recognize the rock formations on the side of the building behind her, and I stopped, trying to place the memory. We were almost at the end of the block, and when I turned around to look at the sidewalk behind us, it clicked.

"This is where I took my first photo!"

"Really?" she asked, indulging me for a moment before shrugging. "Okay, now we have to go."

"Just a second. I have to take a photo."

"But you just said you had one. It was your first!"

"It's for posterity!" I yelled as I hopped off my board and lay down on the sidewalk.

We continued to squabble as I lined up the shot and squeezed off a few photos. "Well, at least I know where we are now," I said, picking myself up from the concrete.

"Okay, how long a walk do we have back to the bus station?"

"Maybe thirty minutes," I said, pulling my watch out from the camera bag.

"How long till your bus leaves?"

"About thirty minutes."

By the time we'd hustled out of the backstreets and across the courtyards, Beth was power walking to keep up as I led the way. After grabbing our bags from the hostel and practically running to the station, we were panting by the time we reached the bus. The vehicle was already idling, and I was the last person to throw my bag into the bottom luggage compartment.

The constantly evolving fraction of hours had turned to minutes: four of them, to be exact. We both sat there, trying to give our last bits of advice to each other.

"Don't drink too much. And don't let yourself get all mopey. You're less attractive when you do that," she said, picking up a small pebble and rolling it in her hands.

"All right. You remember to eat and take care of yourself. And don't let yourself get immediately seduced by some tall Swede," I said and laughed halfheartedly.

Then she grabbed me and buried her face in my shoulder. Her nails weren't long, but I could feel them digging into my back. I put my arms around her and was reminded of how small she was, sitting next to me. She'd always been the tough one, and it hurt to feel her rib cage shake as she cried.

"Don't go," she whispered.

The fraction that sat in my head began to evolve faster and faster, until one minute encapsulated the entire amount of time we had left together. And then that, too, was gone.

We kissed, and I got on the bus, which was already rumbling as I climbed the steep stairs. When I got to the top, I looked down the aisle to see sympathetic faces looking back at me from behind the foam seats.

Not now, I told myself. I felt tears gathering behind my eyelids as I marched to the middle of the bus and sat down by the window. Beth was still standing there, looking up into the tinted bus windows. I pounded on the window, trying to get her attention and show where I was behind the dark glass. She saw me just as we began to move.

Riding the bus, I watched the old streets of Vienna roll into the wide highway that stretched out toward the airport. I couldn't help but think that I'd put myself in the exact same position—with even the same girl—that I had almost a year before, when I left Christchurch to go back home.

Why are you doing this to yourself?
I don't know. I keep thinking I can win.
Win what?
I don't know. I got the girl. I beat the people who stare.
Yeah, well, you see how that worked out. Maybe winning isn't—

"Would you like a cigarette?"

I looked up and saw a thin piece of paper with strands of hand-rolled tobacco poking out the end. Perched above the seat was the man holding the cigarette, a pitying look etched across his face.

"I know it is hard. Maybe a cigarette will help?" he said, his voice rising with the question.

I thanked him but numbly choked out "no."

"Are you certain? It is okay because we will be stopping in a moment at the airport, and I will be smoking as well," he insisted, his German accent stretching itself to sound as helpful as possible.

I smiled. "Nah, thanks though. I appreciate it."

"Ah, it is okay. This is the least that I can do for someone in your . . . um, situation."

He turned just as the bus lurched to a halt outside the departure terminal. As people got off the bus, they gave nods or "I'm sorry's" as they hustled past my seat. Everyone, it seemed, knew exactly what had happened. Even a little boy drawled "sowrry" as his mother pushed him down the aisle, her hand pressing gently between his shoulder blades.

I didn't want to hold anyone up, so I slumped into my seat and waited for the bus to empty. As people passed, I muttered the occasional "thanks" or "it's all right" in response to their condolences.

I sat there, waiting for the feelings of exposure and loathing to wash over me, but they didn't come. The looks that people gave as they left were exactly the same I'd received in countless countries over the past three months. But unlike getting stared at for being a no-legged guy, I realized I was getting sympathy

for losing my girl. In that moment, I wasn't sad or pitiful because of some fictional accident. I wasn't a beggar or a shark attack survivor or a war veteran. I was a college kid who'd just lost the first woman he'd really come to love. And as much as I hated that short bus ride, it was probably the point at which I was the most normal in the eyes of others.

The man ahead of me hadn't offered that cigarette with the thought that it could buy me food or a place to stay for the night. I don't think he did it to pack away or erase his own guilt, either. Maybe—probably—he'd gone through the same thing before. Maybe he knew more about this situation than I did.

I walked down the aisle, squeezing my shoulders between the narrow rows of seats, and thought of the days to come. I still had a couple of stops to make on my trip before my return to the States, but the excitement just wasn't there. I wanted to be home or back in Vienna with Beth—anywhere but on an airplane.

HOME

Sighisoara, Romania

Dad's gray hair stood out like a monochromatic night-cap among the crowd packed into the arrival area of JFK airport in New York.

"Hey, bud," he said, smiling and extending his hand. "Good to see you survived."

His grip was still strong, and he gave one solid shake before turning around and moving toward the exit.

"Uncle Maurice is waiting in the car, so we gotta go," he barked. As we crossed the densely packed parking lot, I noticed that he had a pretty nasty limp on his right side, and though he still moved quickly, his characteristic march had turned more into a hobble.

"What happened to you?"

"Oh. I was driving down some fuckin' backwoods logging road, and my truck bottomed out in a rut. I tweaked myself pretty good. The doc told me that I shouldn't drive or be in a car for a while."

I laughed. "Are you serious?"

"Yeah, it hurts pretty bad. But we still had to drive out from Montana to get your little ass, so I got a big bottle of painkillers to keep me going."

"Well, I could've just flown home from New York. You didn't have to come get me."

"Ah, it's all right. Made this drive a million times, and we all wanted to come out and visit Grandma and Grandpa. Besides, busted back ain't gonna stop me." Dad puffed, trying to straighten out his gait as we headed toward Maurice's champagne-colored sedan.

"Here, give me the bag," Dad said, slapping on the top of the trunk, which popped as I piled into the backseat of the car.

"Hi, Kevin," Maurice slowly drawled, "how are ya?"

"Oh, good. Glad to be home."

"I'm sure. It was a long trip you just had. Well, you can rest before driving up to Poppy and Grandma's house tonight."

The right side of the car sank as Dad opened the door and plopped himself into the passenger's seat.

"Hey, Dad, where are the girls?"

"Oh, the girls? They're *shopping*," he spit out while limply waving his hand. "Meg and Shan wanted to get New York handbags with Mom, so they all went into the city to find some cheap knockoffs. I guess you're not important enough for them."

I laughed as Dad ranted in the front seat, occasionally stumbling over alien words like *Praa-da* and *Goo-chi* while Maurice gunned the car toward his place in the Bronx. The last few weeks had been exhausting. It had been ten days since Beth and I had split, and while I continued traveling solo, my memories of that time seemed almost drained of color. Seeing new sights alone, without Beth, removed their significance, almost as if trying to view them through waxed paper.

When Dad, Maurice, and I finally piled into my aunt and uncle's small duplex, I quickly found a spot to sleep on one of their plastic-sealed couches and closed my eyes. But soon I was awakened by the sounds of shopping bags being crinkled as they were

thrown onto the kitchen table. When I did snap open my eyes, I caught Meagan and Shannon in a dead sprint for the couch, screaming "HI, BROTHER!" just before they dog-piled me further into the cushions.

"Hi," I groaned, trying to breathe through the smothering combination of long hair and overenthused hugs.

"Okay, so check this out," Meagan said, abruptly standing up. She ran into the kitchen and came back with a large, unlabeled plastic bag, from which she produced an absolutely hideous purse made of white formless leather.

"It's Prada, Kev! Tess took us to Chinatown, and I only paid twenty-five bucks for it!"

"I think I'd prefer the bag it came in," I said and was promptly punched hard in the stomach by Shannon.

"That's so rude! Well, we'll show you everything later," Shan said before the two ran off to the kitchen like a couple of trick-or-treaters to reinspect their loot. They nearly knocked Mom down en route, and she was shaking her head as she dove in for a hug.

"Hi, dear. Nice to see you," she said, forcefully enunciating each word. "Come on out to the kitchen and visit with us."

"All right."

As I sat down at the table, which was piled high with more bags, I could hear Dad already starting to argue.

"What took you so long? We've been here over an hour," I heard him grumble to Aunt Tessie. My seventy-year-old, hyperactive Irish aunt had been the girls' guide on the citywide shopping spree.

"Oh, you leave them alone, Brian! They wanted to shop, so I took them shopping, and that's it," she jabbed back at him, her brogue sounding full force.

"Jesus. Well, we gotta hit the road soon. We got a long drive up to Connecticut, and Poppy and Grandma are already waiting for us."

Tessie turned toward me as she dropped down into a seat across the table from me.

"Well?" she asked, waving her hand at me. "How was it?"

I looked up, distracted. "What?"

"The trip! Don't be funny!"

"Oh yeah . . . " I mumbled, looking around the kitchen. My sisters and parents had stopped bustling for a moment and were looking at me as well.

"Oh, it was good," I finally said as I looked down at the table, trying to end the conversation gently.

I should've seen that question coming and been better prepared. Of course everyone on Dad's side of the family knew that I'd just gone on a big international trip, and I would be interrogated over the next week. Word had spread about my involvement with Beth, and in a big family of Irish Catholics, I knew it was only a matter of time before I'd be asked about how soon I was planning to put a ring on her finger. Questions would range from how my skateboard held up to what my favorite city was.

The only thing I didn't expect to talk about was the motivation for going on the trip: the photo project. It was something I tried to keep quiet among my extended family, because it never seemed all that impressive. "Yeah, I rolled around the world and got stared at," sounded more like ninety days of narcissistic indulgence than work on a cherished idea.

So maybe instead of muttering that the trip was "good" to Aunt Tess, I should have said that initially I felt disappointed. The project that had kept me going for the past year was largely

finished, and with it, the catharsis of that shutter click that had kept me from losing my cool at more than a few people over the past months. I realized that it was going to be harder for me now, with the loss of such an effective emotional release valve.

Also gone was the feeling that I was doing *something* with my lack of legs. This photography had allowed me to use my leglessness as a way to create an art project that otherwise would have been impossible to produce. The movement, the low angle, the stares: they all added up to form images that couldn't have been taken by anyone else. That point of daily pride—that I was doing something that others couldn't, for once—was now gone, leaving only the sensation of someone who has reveled too much in his own ideas.

When we got to my grandparents' house hours later, a small welcoming delegation had formed in their sitting room. Dad's six brothers and sisters were spread out across the eastern seaboard, and a fair number of them had shown up to say hello. Compared to the past few months, it was strange to again be part of a family, or even just surrounded by people who wanted to talk both at and to you. My mind quickly began to fill before popping like an overloaded circuit. All I could manage were short, stale responses to the questions that they flung out.

"*Yeah, it was a lot of fun.*"
"*Nah, Beth and I aren't together.*"
"*The skateboard held up all right. The gloves didn't.*"
"*The coolest city was probably Split, in Croatia.*"

It was great to see everyone again, but visiting with Dad's family made me yearn for a return to Montana even more. I was

surrounded by people who I knew and loved, but still living out of a backpack and still jet-lagged. So by the time we'd begun to pack up the new SUV that Mom and Dad had purchased the month before, I was ready to leave.

Dad was incredibly protective of the new vehicle and limped around it shouting, "You hurt my new seats, and I'll kill you," with a tone that almost convinced us he had a shiv in his pocket.

We'd planned on approaching the 2,300-mile drive pragmatically. If we did it fast enough, we could avoid most of the discomfort associated with having five family members and their belongings crammed into a small vehicle. The plan was to switch drivers every four or five hours, so we could keep the vehicle running both day and night.

The schedule sounded ambitious, but as Dad said, we'd done it a million (read six) times before. But on this trip, Dad's bravado caved before Pennsylvania, and he quickly moved to the backseat, almost incapacitated with back pain. The miles that he'd shouldered alone during those previous journeys now had to be divided between the remaining four of us, and we quickly realized how impressive his endurance (or stubbornness) was. Our admiration was short-lived, though, as he quickly turned into a grumpy old bastard, driving not just from the backseat, but from the *very* backseat . . . while lying down. He was popping the heavy painkillers like candy and washing them down with beer as he told us how we should be handling his new car.

That first night, I sat behind the wheel as the car sped through Ohio on a deserted Interstate 80. Mom sat beside me, changing CDs as Dad yelled at me to keep my speed in check.

"Dad, I'm doing seventy-five," I hollered back, exasperated.

"Well, you're fucking bouncing all over the road!"

"Brian!" Mom piped up, trying to stem his flow of curse words. He quieted down just enough for us to drown him out with the new CD.

"He does this all the time," Mom said, looking over at me. "He overextends himself and then makes us deal with his griping.

He's a pain in the ass," she added, "but no one here would be who they were without the combination of the both of us. I probably would've babied every one of you."

I nodded. As giving and kind as Mom was, she was also a bit of a pushover. She was the ultimate softy of the house and was the first one we'd run to if we were about to get into trouble. Predictably, she would always defend and compliment us, even when we probably weren't deserving of the praise.

It's not that their faults bothered me. I'd experienced Dad's surliness and Mom's clemency nearly every day for the first eighteen years of my life. It was just that ever since first going to New Zealand, I'd been slowly distancing from them. This, I knew, was a fairly normal thing for most kids going through college, and I didn't pay much mind as I bounced around the globe, spending increasingly shorter and shorter amounts of time at home.

I kept only one family photo with me when I traveled. It was a small Christmas photograph, with my family all lined up together in the darkened living room. I looked at those faces quite a bit; sometimes it would be a red-eye flight in the back of the plane, sometimes in the shade of the low bunk in a hostel.

But as I sat next to Mom, it hit me that I'd allowed myself to forget what my family was like to spend time with. I'd looked at that photograph so much, imagining what each reunion would be like, that I began to almost romanticize my family, forgetting

their faults and convincing myself that everything would be perfect once I made it back to Montana.

I looked over at Mom. She did look older than I remembered, and I looked up into the rearview mirror to see Meg and Shan behind me. It hurt a little to realize I'd been focusing so hard on my trip that I'd neglected to see the other things playing out beyond my vision. I'd missed a summer in Montana, and one of the last in which my sisters and I would've spent beneath our parents' roof. Meagan was headed to college next week, and Shannon was going to start her senior year of high school. Dad was keeping busy trying to build a new deck for the back of our house, and Mom had just started working for the Helena chapter of Eagle Mount, the adaptive sports organization that first got me skiing.

They had been changing and working as much as I had, and I smiled to myself as I thought about the line Mom had given me years ago, at the Big Sky races. I was happy she didn't have to repeat herself, but even happier that I'd come back to it on my own.

"This isn't just your show."

The words stuck with me.

I'd traveled around the world, "won" the girl, and finished this crazy photo project. But as I watched the odometer change itself over another mile, I began to realize how ephemeral those accomplishments were. I'd lost the girl (for a second time, no less). Despite all those snapshots, I still got rankled at someone staring. And even though I'd managed to travel to so many different places, by tomorrow I was going to be back where I started. I expected to feel hurt, thinking that everything I'd worked for had dissolved, but the feeling just wouldn't come.

All those years of skiing and racing and trying to keep up with those around me had created a ridiculously competitive way of looking at the world. I wanted to win everything, even the stuff that was impossible. I never wanted to be the last one in line, or the guy to lose the girl, or even the person to exist passively while getting ogled.

So when people stared, I returned fire with my lens, trying to find the upper hand in a fight against a formless competitor. When Beth and I split up the first time, I tailored my trip through Europe around hers so that I could win her back.

And then there was the last competition: *trying to keep up*. This, probably more than any of the others, was the most important (and impossible) contest to win. On all of those camping trips with friends and family, I never wanted to be the slowest. My age, or the group of people I was with, didn't matter; I'd always been saddened anytime I ended up as last of the pack. Words like "slow," "dawdling," and "defective" resounded in my mind as I tried to keep up with strides that were greater than mine.

Deep down inside, I *knew* that I couldn't physically keep pace with the others. I *knew* that I would always be dead last in a hike. I *knew* that, no matter my training, I'd probably never be able to truly keep up. It was a hopeless goal to hold myself to, so I began to compensate through travel. I figured that if I couldn't win in speed, I could win in distance. I'd certainly felt a strong sense of pride whenever I was given a chance to speak about my travel plans. But it never dawned on me that I might be the only one keeping score in this illusory competition, or that all that time away from family and friends might come at a cost.

We were getting older—all of us, all of the time. And with the

advancing years came changes in what it meant to *keep up*. Our family hiked less now, and most of my friends were finding themselves in the throes of early adulthood, drifting apart due to work, internships, or school. With time together becoming scarcer by the year, the concept of keeping up had become less a physical issue and more a social one. It might be impossible to put aside enough time to organize a weeklong camping trip, but now that I was coming home, at least I could go to dinner with friends and hang out with my family. The time spent might be less dramatic an experience than traveling across Europe but no less valuable.

For the first time since I arrived in the United States, I felt truly happy about being back. It was good to be near Mom, even if she was a pushover; Dad, even if he was a pain; and my two sisters, even if they were both asleep, drooling onto each other's shoulders.

About eleven thirty we pulled over to switch drivers, and Dad, who was feeling better, decided that he'd take the wheel. I climbed into the way back and was just getting ready to drift off to sleep when Mom yelled, "Five minutes, Kev!"

I'd forgotten. It was August 18—our shared birthday.

I stared over the shoulders of my sisters and parents and out into the short horizon that our lights created on the road, waiting for the minutes to pass.

When Mom turned fifty up in the front seat, she gave a little whoop as the dashboard clock clicked over to midnight, while five feet behind her, I was turning twenty-two. Soon we'd all be home under the same roof, if only for a short time. I started to go back to sleep, happy to know that, for once, I wasn't responsible for the wheels rumbling on the asphalt below.

EPILOGUE

Old Hands

F or most children, their first means of getting around is to crawl. Scrambling clumsily across the ground on their hands and knees, an infant's little fingers explore the floor of the home they're raised in. But as the infant grows to be a toddler, those hands push away from the ground, and those soft feet begin to bear the burden that the hands once did. In slow, halting steps, the toddler begins to walk and talk and bloom into a child and a teenager and an adult. Those hands won't often touch the ground again.

I learned to crawl at the same age as everyone else, first grasping the puke-green shag carpet of my parents' living room at eight months. But much like my development in the womb, things took a turn at a certain point. My legs stopped growing at the pelvis, and my hands never left the carpet. So while my legs never matured past two tiny nubs the size of a button, my hands made up for it by pushing and pulling the rest of my body where I wanted to go.

As these pages show, my lack of legs has generated a lot of strange looks. Those stares still get to me sometimes. Sometimes I wonder if I should explain myself to the people who shoot a sad gaze in my direction. Maybe, if it would relieve that moment of guilt or pity from their lives, it would be worth it. But most

226 } *Kevin Michael Connolly*

of the time, I let those stares slide off my back. A lot of times, I don't want to talk about lacking legs.

Maybe it's because dialogue has a tough time blooming when it's about negative space. There's only so much you can discuss about something that isn't there, and isn't forthcoming. And rather than try to make a bad riff on a Beckett play, I'd prefer to end this page with what I do have.

I'm sitting here looking at my hands resting atop my keyboard. Bitten and torn, my fingernails bear the rusty black marks of a forgotten injury weeks ago. My knuckles, bloated with the early signs of arthritis, break each finger into three segments that flex woodenly. My palms—big, meaty hunks of flesh the diameter of a softball—were inherited from my grandpa, who referred to his own set as "mitts."

My wrists join these old hands to forearms that look more like someone's calf than the lower components of an arm. Veins pop and twist up to my elbow, where the muscles take a turn to my upper arm. Bursitis-filled and wrapped with muscle, my shoulders plunge into the body, heart, and head of a twenty-three-year-old guy.

Originally, I didn't want to write a memoir. The genre felt too loaded for me; I whined and griped about how unqualified I was to write a retrospective on such a short life. If I'd written each insecurity down on a separate sheet of paper and then stacked them together, they would be thicker than this book.

The only reason I kept at it was the realization that my life is not entirely my own. Instead, who I am is the influence of hundreds of people who have helped to get me to the point where I am now. So yeah, I was born without legs, but that's only one small aspect of my life so far. The influence of my missing legs

doesn't extend past getting stared at, or creating my knocked-about hands. Instead, the reason I am who I am today is because I have a crowd of tough (if not slightly crazy) folks who've got my back.

And I have come to understand why people make up stories and ask questions about what happened to my legs. I'm guilty of doing the same thing to others who interest me. It's a natural human imperative to create stories: things can't just *be*. If someone gets lung cancer, we want to know whether he smoked. If someone has a heart attack, we want to know if she ate unhealthily. But less often do we want to know about people's country or culture or family that constructs the real narrative behind who they are.

So maybe the reason I've been so frustrated at times by the question What the hell happened to you? is because it's simply the wrong one to pose. It focuses too much on a physical circumstance based on a singular point in time, rather than on all of the influences and characters that followed.

Perhaps Where the hell did you come from? is what we all should be asking.

ACKNOWLEDGMENTS

This book *would* not have been possible without the patient and guiding help from everyone at Harper Studio. Thanks especially to my editor, Julia Cheiffetz, for being blunt and pushing when it was needed. Thanks as well to my agent, Caroline Greeven, for her early interest and calm advice, and to the Stapleton family for their hospitality—you kept me sane during the writing of this book. My gratitude also goes out to Deidre Combs, Steven Rinella, and Marc Gerald for the long conversations and guidance over the past year.

Thanks to both my new sponsors—Ironclad and Sector 9—and old ones—Ph.D. Skis, Extreme Roofing, Dave Sullivan, Poppy Connolly, and Eagle Mount—as well as to all the Helena locals who helped out when I was a kid.

Finally, thanks to my family for all of their friendship and support over this short life. By blood or not, you know who you are.

ABOUT THE AUTHOR

Sarah Nutsford

Kevin Michael Connolly was born in Helena, Montana, in 1985. Born without legs, he was an otherwise healthy baby and grew up like any other Montana kid: getting dirty, running in the woods, and getting dirty some more. Kevin attended Montana State University in 2004, with majors in both photography and film production. Funded by a second-place finish at the 2006 Winter X Games, Kevin took a skateboard and backpack on a tour around the world to more than seventeen countries including Bosnia, China, Ukraine, and Japan. Along the way he captured over 33,000 photographs of people staring at him. These images evolved into a photo collection entitled The Rolling Exhibition, which has garnered international media attention and has been featured at museums and galleries around the world. Visit Kevin online at www.kevinmichaelconnolly.com.